CHICAGO PARKS REDISCOVERED

Published by
Jannes Art Press, Inc.
4840 W. Belmont Avenue
Chicago, Illinois 60641

For additional information on photos,
contact the photographer through:
www.frankdinaphoto.com

First Edition
Printed in U.S.A.

ISBN #0-912223-02-2

Library of Congress
#2001119422

CHICAGO PARKS
REDISCOVERED

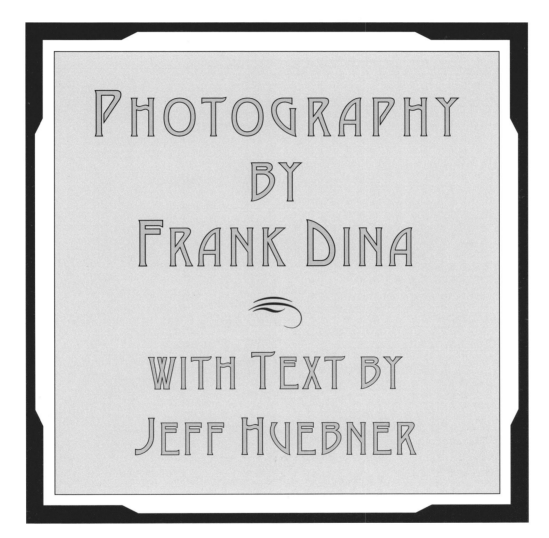

PHOTOGRAPHY
BY
FRANK DINA

WITH TEXT BY
JEFF HUEBNER

JANNES
ART PRESS
INCORPORATED

CHICAGO USA

ACKNOWLEDGMENTS

A project like this would not be possible without the help, support, and input of many people and organizations.

Early in the project the Garfield Park Conservatory Alliance took an interest in my work and used it in several applications. Erma Tranter of Friends of the Parks suggested several good locations and gave me valuable input throughout the project.

Steve Dalber provided a well-equipped and well-maintained color lab at Wright College for my photographic printing. Meg Gerkin gave guidance in the early stages of this project. Michelle Kiem, also of Wright College, was the first to suggest a book from this project. I also would like to thank Marianne Taylor from Gallery E.G.G. Friends who came to my assistance are Joanne Rosellini for editing the text, Bruce Berg and Jim Sterne for creative input.

Matthew Smith brought this project to the attention of the Chicago Park District and the Mayor's office. Among the people at the Chicago Park District who gave support in various forms are Drew Becker, Robert Megquier, Lara Khoury, Efé McWorter, and Julia Bachrach. In the early stages of this project The Department of Cultural Affairs provided CAAP grants.

I am also very grateful to Michael Intrator and Phillip Ross of Jannes Art Press. Michael Intrator had the insight to see the full scope and value of this project. Phillip Ross provided the design, look, and planning for this book. Skilled people at Black Box Collotype who produced and printed this book took great care to successfully reproduce the color photographs. They push the printing of photographs to the highest level. I also want to thank Jeff Huebner for writing an eloquent and informative text and for his skillful synthesis of the history of Chicago's parks.

This book was made possible by a grant from The Graham Foundation for Advanced Studies in the Fine Arts.

Substantial support was also given by Bob Wislow of U.S. Equities Realty. Their interest and input at the latter stages of this project helped to insure that it had the direction and resources to be completed.

Most important of all I would like to thank my wife, Patricia, for her critique, editing, perspective and encouragement. Throughout the last five years of the ups and downs of this project she gave me reason to keep going.

FRANK DINA

Parks are a necessity for the cultivating and preserving of a love for nature. They are the seats of learning for the average city-bred being....Parks are practical schools of horticulture and the bone and sinew of municipal art out-of-doors. They are necessary for the self-preservation of those who by free will or through forced circumstances have made their homes in a large city.

Jens Jensen, Chicago Landscape Architect

Photographer Frank Dina had a unique vision when he set out, in 1996, to take pictures in Chicago's neighborhood parks. "I just wanted to refocus people's eyes and attention, and have them look at these parks in a different light," he says. "I wanted to show that, even though they're sometimes located in economically depressed areas, these parks aren't depressing places to be. They're uplifting places that should be taken care of, used, and enjoyed." With this book, Dina is inviting us to look, and then to go out and look again – to experience the "municipal art" in our backyard that many of us have never visited.

Places such as Humboldt Park, Garfield Park, and Columbus Park, as Dina's photographs reveal, are, as he says, indeed "islands of beauty and peace in the midst of urban surroundings." The city and its surrounding neighborhoods are literally and figuratively just beyond the frame. Yet what's beyond the frame in these pictures is perhaps as significant as the scenes of naturalistic landscapes themselves – the union of country and city, of nature and culture, of the wild and the contrived. Viewers must have a wider frame of reference. Chicagoans often confuse a park with its neighborhood, because in most cases the neighborhood's name is the same as the park's; consequently, a person's idea of the parks can be influenced by their perceptions of the surrounding neighborhood.

Dina wanted to look beyond the names and associations, see past the misperceptions, and focus on parklands where people of all colors and classes, people who cannot always easily escape their urban environment, can mingle and engage in a multitude of activities. Then he wanted to share his discoveries – and rediscoveries – with us. A lifelong Chicagoan with a background in socially oriented filmmaking and landscape photography, Dina is really performing a public service: by trying to disassociate a particular park from the reputation (whether right or wrong) of its community, he's also restoring to the park, and the neighborhood, a good name.

In doing his parks project, Dina had another purpose: he wanted to help restore the oft-maligned reputation of government-run public services – in this case, the Chicago Park District, an autonomous city agency that receives funding from governmental bodies, fees, and donations as well as from tax dollars. A private service, which exists to produce profit, has little incentive to meet the needs of communities that do not pay for them. But the park system, as Dina shows, is an example of a public institution that, despite past accusations of inefficiency, neglect, and even corruption, generally functioned well and, as he says, "still produces and protects these wonderful places that can be of great benefit to the community."

Many of us have visited and enjoyed our lakefront parks – Lincoln and Grant, for instance. But the "outer-ring" parks, especially those of the old West Parks system, are often more heard about, read about, or seen in historical reproductions, than actually experienced. But they are vibrant, living landscapes with their prairies and wetlands and woodlands and lagoons, with their changing seasonal vegetation and colors. They have architectural treasures, too, with their fieldhouses and refectories and bridges and pergolas. Dina wants to show us that it's all there. "I wanted to shoot parks that weren't heavily used by a lot of people, though they are used by people in their neighborhoods in very normal ways," he says. "I felt that

these parks hadn't been photographed very much recently. And they hadn't been photographed in color very much – and that was one thing I thought was important because many of us visualize them as old, sepia toned photographs. Color brings these parks into the present, makes them feel more immediate."

Dina lugged around what he calls a "clunky, out-of-fashion" camera, a medium-format, twin-lens reflex Mamiya C330 from the 1970s. It's all mechanical, with no electronic parts. He generally used a moderate wide-angle lens, which, along with the camera's square frame, enhanced his photographs' sense of space and scale: in a single shot, he could capture whole swaths of land, water, building, and sky, emphasizing a park's natural and constructed features, the sense of idealized nature and the picturesque landscape. These pictures – which are actually compositions of compositions – aim to tell us we're in an urban park, not in the pastoral countryside, although we realize in some instances that our eyes could be tricked, just as our parks' designers meant for them to be.

Here I'm reminded of the work of French photographer Eugene Atget (1857-1927), whose pictures of Paris parks and gardens were among the first and greatest of the genre. As John Szarkowski points out in an essay included in Viewing Olmsted: Photographs by Robert Burley, Lee Friedlander, and Geoffrey James (published in conjunction with an exhibit organized by the Canadian Centre for Architecture): "Atget learned that just as a garden was an artificial reinvention of nature, so was a photograph of a garden a subsequent act of artifice, requiring reconsideration of the idea in terms of photography's own limitations and potentials."

I think there's something else Dina's photographs do: they "humanize" parks – even though there's a conspicuous absence of people here. It wasn't always that way. Initially, Dina had a much broader scope: he took a lot of pictures of people using park facilities – playing sports, fishing, hiking, working, participating in cultural activities, or just relaxing. His intent had been to document use. But that became a separate body of work, a series he decided not to include in these pages. Instead, Dina turned his attention more toward the landscapes and the buildings where these activities took place. So what's been left out, what's absent, has still in a way been left intact: use still has presence.

Dina, who photographed natural features of the southwestern United States before he began his parks project, believes his work focuses on what he calls the "social aspects of landscape photography." To illustrate, he points out how Ansel Adams' photographs of the West, like those collected in Yosemite and the Range of Light, captured the mystical beauty of landscapes at the same time they made an ennobling environmental statement and helped to spur conservation of national parks and public lands.

In another sense, Dina has documented the work of late 19th and early 20th century park architects such as Frederick Law Olmsted and Jens Jensen who themselves set out to humanize both urban and natural environments. Like them, Dina aims to show how the cultivated city landscape can help promote the notion of "social cultivation" and shape a more democratized civic realm.

...the cultivated city landscape can help promote the notion of "social cultivation" and shape a more democratized civic realm.

That may be a utopian ideal, given the location of most of these parks' neighborhoods; then again, they are – or once were – utopian landscapes, and this is an idealist's vision of them. Dina would like us to picture parks in the way they had originally been envisioned – as "people's gardens," meaningful, delightful public places for everyone.

I know firsthand what Dina means. As long as I've been a Chicago resident, since 1986, I've lived blocks away from Humboldt Park, on the west side. Since 1870, when the park was designed by William Le Baron Jenney, better known as the father of the skyscraper, the adjacent community has changed from Jewish, East European, and Scandinavian to predominantly Puerto Rican and African-American. Park improvements were made from 1906 to 1909 by Jensen, then the chief landscape architect and general superintendent of the West Park Commission. The Danish-born Jensen was a pioneering figure in the "Prairie style" of landscape design: he believed that the forms and materials of parks should relate to the surrounding region, and he advocated the use of native plants and other features that evoked the spirit of the prairie and the midwestern landscape. Like other naturalistic park gardeners, Jensen maintained that his designs were idealized emulations rather than literal re-creations of nature, and that they were works of art as well as places of play.

But I knew little of this, at first; I only responded to Humboldt Park's "natural beauty" and didn't always have a sense of it as a place that had been shaped and sculpted from land that had once been flat and boggy and desolate. I've spent many an enriching hour, in all seasons, rambling or riding my bicycle on its winding paths, over its broad meadows and gentle hills, and through its wooded groves. I've sat beside its prairie river, read books beside its cattail marsh, swum in its summer-flooded pond, sampled ethnic foods from its mobile food stands, picnicked in its sunken rose garden, and perused its eclectic collection of 19th-century commemorative statuary. I've attended its outdoor neighborhood festivals as well as cultural exhibits in its classic fieldhouse and fantastically restored stables building. Despite perceptions that the park is unsafe, I've never encountered any problems there; it has always been for me a place of refuge, reflection, and regeneration.

I was gratified to learn it was Humboldt that sparked Dina's parks photography project and, ultimately, this book: "It's what really got me thinking about seeing parks in a different way," he says. A longtime resident with his wife Pat in the city's Ravenswood area, Dina used to spend time bicycling through the park, too, and was captivated by its splendid pictorial qualities. Then he began coming back, equipped with his camera and a new pair of eyes. In the Southwest, which abounds with intriguing natural

scenery and photographic possibilities, Dina says he just had "to find something" and shoot. But setting up shots in Chicago's parks was a different matter. He discovered it was as if park architects "set the artificial scene for you, which made my job easier," he reports. With these scenes, we not only see a photographer picturing parks; we also see an artist rediscovering his city.

Chicago has been blessed with an uncommon wealth of public parks, ranging in size from the 1,212-acre Lincoln Park, which stretches almost six miles along the shoreline, to pint-sized playlots. But the historic, scenic, and restorative qualities of some parks are not generally well-known to residents, much less to out-of-town visitors. Several of the most classic parks – largely by dint of social

geography or by changing neighborhood populations and use patterns – remain underseen, undervalued, misunderstood, and missed.

Yet the very fact that parks – not to mention a city – had been carved out of the land here was a miracle in the first place. Early settlers encountered a bleak, unappealing swampy morass, surrounded by a monotonous expanse of desolate prairie. Still, when Chicago was founded in 1837, city fathers adopted the motto *urbs in horto*, or "city in a garden." It's not altogether certain what they meant. Did the "garden" refer to the outlying prairies (within which the city was set), or did it refer to the horticultural gardens and the few small parks (set within the city itself) that defined it as an urban area? As in other upstart American cities, settlers brought with them English and French landscape gardening traditions, which they applied to both private grounds and public promenades. The ideas of town and country, of the urban and the horticultural, at least in early Chicago, seemed intertwined.

In 1849, civic and real estate booster John S. Wright proclaimed: "I foresee a time, not very distant, when Chicago will need for its fast-increasing population a park, or parks, in each division. Of these parks I have a vision. They are all improved and connected with a wide avenue, extending to and along the Lake Shore on the north and south, and so surround the city with a magnificent chain of superb parks and parkways...."

Wright's vision began taking shape 20 years later, a time when Chicago – driven by rough-and-tumble business interests, uncontrolled growth, and runaway materialism – was the fastest growing city in the world. In 1869, the Illinois legislature passed a Chicago parks bill that aimed to give the city the "finest system of public parks in the world." It established three separate, independent systems: the South, West, and Lincoln Park Commissions; each district was an autonomous body governed by its own board of commissioners, with powers of taxation and acquisition. The bill created a plan for developing a "green belt" of large pleasure grounds, linked by landscaped boulevards, all the way around the settled edges of the city. Public park area was expanded from about 125 acres, less than a third of them improved, to over 1,800 acres.

As historian Donald L. Miller writes in City of the Century: The Epic of Chicago and the Making of America:

"The park program...was Chicago's first effort to shape a development process dominated by unruly improvisation and to plan entire areas in advance of settlement for public, not private, use. It was also the first successful effort in the city's history to break the monotonous spread of the grid."

Chicago's earliest parks, not surprisingly, had been built to make money. Aside from such promenades as Lake Front Park, real estate speculators created small public grounds and squares to enhance the beauty and value of their adjacent properties as well as to promote urban growth: parks became the centerpieces of fashionable developments built beyond the commercial marketplace and working-class districts.

The success of New York's Central Park, designed by Frederick Law Olmsted and Calvert Vaux in 1858, spurred Chicago's parks movement. Olmsted is seen as the father of American landscape architecture, and his plan for Central Park is often cited as the beginning of naturalistic park design in America. Olmsted was impressed by England's 18th century landscape parks (created out of concern for the nation's vanishing hinterlands as well as in reaction to its formal gardens), and in his designs he sought to suggest the scenery of the rural countryside. A former public-health reformer, he believed that nature's beauty was a healthful antidote to pestilential city life, and that urban parks had a restorative effect on the mind, body, and soul. For Olmsted, parks were also civilizing, democratic places where both the poor and the wealthy could gather together.

The civic leaders, most of them real estate profiteers, who inaugurated Chicago's park system in the 1860s weren't as concerned with social reform. They were led by lawyer and speculator Paul Cornell, who saw how Central Park had greatly increased the value of its surrounding Manhattan land, and he began campaigning for a South Park Commission to create pleasure grounds in the vicinity of Hyde Park, an exclusive residential enclave he'd developed several miles south of Chicago (it's now part of the city).

Yet park boosters weren't wholly motivated by mammon. As historian Daniel Bluestone points out in Constructing Chicago, 19th century American city dwellers sought a closeness with both nature and civilization; parks combined both elements, reflecting the ideals of progressive urbanism and cosmopolitan refinement. "Many urban residents," he writes, "viewed park development as the act of a civilized community, a community capable of turning away from the pursuits of commerce to create a public realm for refined leisureSimply put, idealizations of urban as well as rural life informed the notion of cultivation that guided park development." Bluestone adds that such notions were largely informed by bourgeois sensibilities, and that "the cultivated city landscape bespoke aspirations toward refined individual character and a harmonious urban society."

But it was not that simple. The first parks bill, introduced in 1867, was voted down by south-side residents, the majority of them laborers and the poor who lived too far from prospective parklands. For people who worked long, hard hours and lived in increasingly crowded and disease-prone inner-city areas, however, urban parks offered public-health advantages. They had an advocate in Dr. John H. Rauch, a member of the Chicago branch of the Sanitary Commission and a friend of Olmsted's. In 1869 he published the influential booklet Public Parks: Their Effects Upon the Moral, Physical, and Sanitary Conditions of the Inhabitants of Large Cities. He discussed how park foliage – the "lungs of the city" – would disinfect the contaminated air, and how pleasant, pastoral scenery would help ward off the temptation to indulge in urban vices. Parks would reform the lives of "ordinary toilers."

Backed by Cornell, by north and west side real estate interests, as well as by social and sanitary reformers, a more equitably distributed, city-wide system of parks and boulevards gained broader public approval – its strongest support came from middle- and upper-class residents – and the revised bill became law in 1869. Chicago's parks program founders had campaigned that every person in the city would be within a half-hour's horse-car ride from a park. Still, the new plan did not make them easily accessible to all; early on, the "people's gardens" were mostly the domain of the privileged, being some distance away from the neighborhoods where most people lived.

The biggest reason Chicago was able to build a world-class park system...was that it attracted the world's best park builders.

The biggest reason Chicago was able to build a world-class park system – outside of grit, money, clout, and in some cases even graft – was that it attracted the

world's best park builders. The Great Fire of 1871, followed by the financial panic of 1873, hindered parks' progress, and not all of the original park plans were implemented. Yet by the 1890s, the expanding metropolis could truly claim to be not just a city in a garden, but a city of gardens. Cheaper and improved public transportation as well as the development of workers' subdivisions at the city's edge led to an upsurge in park usage. "All the parks, however, remained alien territory to the city's inner immigrant neighborhoods," Miller writes. "A round-trip car ride for an entire family could have easily eaten up half a Polish mill hand's daily wage."

Rauch had wanted Olmsted's firm to design the entire system of parks and boulevards, but the plan was never realized; the three new park commissions operated independently, so each hired its own designers. Swain Nelson, a Swedish landscape gardener and local nurseryman, was commissioned to continue improvements he'd already begun in the 60-acre Lincoln Park. Numerous northward extensions were made over the years, most notably in the early 20th century by O.C. Simonds, who promoted a midwestern style of naturalistic landscaping. With its lakefront location and beautiful views, Lincoln Park became the most popular public ground in Chicago by the 1880s, and perhaps the most democratic, owing to its proximity to newly-built workers' districts. On weekends, thousands flocked to the park to enjoy its artificial lagoons, picturesque plantings, floral displays, lawn areas, civic statuary, ornamental fountains, and ball fields; there was also a refectory, a conservatory, and a zoo (today, the only free zoo in the nation).

In 1870, the South Park Commission retained Olmsted and Vaux to design the 1,000-acre South Parks system, an area larger than New York's Central Park; it's now composed of Jackson and Washington Parks, and the connecting Midway Plaisance. Olmsted tried as much as possible to work in harmony with each site's natural features – Washington Park's mostly treeless prairie and Jackson Park's swampy lakefront. The latter remained largely unimproved until Olmsted returned to lay out the magnificently aquatic-themed grounds for the White City of the 1893 World's Columbian Exposition, a plan that included lagoons, basins, canals, and a wooded island. By 1900, his sons – the firm of Olmsted, Olmsted & Eliot – created such elements as scenic greenways, foliage, walks, and bridges. A few years later, the Olmsted Brothers designed Sherman Park.

The 585-acre West Parks system – consisting of the boulevard-connected North Park (later renamed Humboldt), Central Park (Garfield), and South Park (Douglas) – proved the most daunting challenge because of its flat, uninviting site miles from the lake and its lack of picturesque scenery. But when William Le Baron Jenney, a former landscape planner and an Olmsted associate, was appointed the system's chief engineer, he transformed the land into a pleasure-ground masterworks. His designs were partly influenced by the parks and boulevards of Paris, and featured (especially in Garfield and Humboldt) changing romantic vistas, lush plantings, winding pathways, ornamental lagoons, and formal plazas. Jenney also brought distinctive architecture into the parks, including bandstands, bridges, shelters, and greenhouses. The creation of these parks had another effect: they precipitated real estate development in surrounding areas, resulting in neighborhoods that took their names.

Jens Jensen was appointed head of the West Parks in 1905, a job he held until 1921. He found its three large parks in a dilapidated condition, with many sections left unimproved, and was able to develop new designs based on his views of the midwestern landscape. While Jensen drew from the naturalistic tradition that preceded his work, as Chicago Park District historian Julia Sniderman writes in her essay "Bringing the Prairie Vision into Focus" (included in the exhibit catalog for Prairie in the City: Naturalism in Chicago's Parks, 1870-1940), "He revised, however, many of the originally planned elements with features that emulated the native landscape. He lessened the amount of space that Jenney wanted to devote to water and instead developed broad horizontal meadows. In Humboldt Park, he modified the lake to resemble a prairie river. To recreate the natural rivers he saw on his trips to the countryside, Jensen designed hidden water sources that supplied two rocky brooks that fed the existing lagoon."

Jensen also hired some of his Prairie School architect colleagues, including Dwight H. Perkins, William C. Zimmerman, and Hugh M.G. Garden, to design such structures as fieldhouses, boathouses, refectories, music courts, pergolas, and in Douglas Park, a "Flower Hall."

Whether built in naturalistic or formal settings, the buildings and the landscapes were intended to complement each other – form a picturesque scene, as it were. Jensen's most stunning achievement was the Garfield Park Conservatory, built in 1907 to replace each of the three park's small greenhouses. Recently beautifully and carefully restored, it remains one of the largest gardens under glass in the world, and one of the first to display plants in natural-looking, landscaped settings.

As landscape architecture historian Robert E. Grese writes in Jens Jensen: Maker of Natural Parks and Gardens: "For Jensen, the large parks encouraged emotional and spiritual release and served as places in which people could regain contact with the cycles of nature. Emphasis was given to creating large, open spaces that seemed endless; small, intimate spaces in which people could be alone; gathering spaces for conversation and celebration; places where people could watch the sun rise and set; and a general background of plantings that changed dramatically with the seasons." Although he believed his landscape designs should not subordinate aesthetics to play, Jensen advocated that urban parks should also serve as community centers, places where both children and adults could engage in organized activities to help promote a more democratic society.

By the turn of the century, rampant industrialization had bred a variety of public-health problems in Chicago, especially among low-wage immigrant workers who lived in densely populated areas without adequate housing, sanitation, and breathing space. In 1904, spurred by progressive social reform ideals, the city-appointed Special Park Commission released a report that developed a plan for a system of small parks, playgrounds, and other recreational sites throughout the city. Soon, nearly every neighborhood had its own park, making the system widely accessible to all people for the first time.

In 1916, Jensen designed what may well be his masterpiece. Located on Chicago's far west side, the 170-acre Columbus Park, included native plants, stratified stonework, a prairie river, ridges, spring-fed waterfalls, a swimming hole, a children's play area, a golf course, a players' green, and "council rings" for storytelling. The park, Jensen later wrote, "is as much an attempt to realize a complete interpretation of the native landscape of Illinois as

Parks not only shape... their surrounding communities; they are, as well, shaped by the changing needs and missions of their inhabitants...

anything" he'd ever done. He added, "Looking west from the river bluffs at sundown across a quiet bit of meadow....gives the feeling of breadth and freedom that only a prairie can give the human soul. Moonlight nights are equally inspiring and are an important part of the landscape composition."

But since the onset of World War II, many of our classical and Prairie-style landscape compositions have been altered or despoiled due to such factors as urban development, the accommodation of the automobile, the need to include various sports fields and facilities, vandalism, lack of funding, fear of crime, and general neglect. As Grese points out, park designers began abandoning social reform ideals during the Depression – Chicago's three park commissions were consolidated into the Chicago Park District in 1934 – and instead emphasized parks as functional recreational spaces rather than as beautiful and picturesque works of naturalistic art. Another thing happened too: as city dwellers became increasingly mobile, they could drive to the countryside rather than have versions of pastoral scenery brought to them. Yet, many of the natural and architectural features created by visionaries such as the Olmsteds, Jenney, Nelson, Simonds, Jensen, and his disciple Alfred Caldwell – who designed the Montrose Point and Promontory Point extensions – remain intact, and in many cases have been preserved and brought back to their original states. Despite the evolving (and devolving) urban landscape, the Chicago Park District has assured their legacies.

As Chicago's neighborhoods have changed, so have their parks. Parks not only shape and define their surrounding communities; they are, as well, shaped by the changing needs and missions of their inhabitants and users. To stay vital and valuable, neighborhood parks have to continually reinvent themselves. And the Park District, working with local community groups, park advisory councils, and advocacy organizations such as Friends of the Parks and Open Lands Project, has responded to changes in the social and urban environment – and reinvented itself as well.

In 1982, for example, the U.S. Justice Department brought a lawsuit against the Park District, charging the agency with underserving African-American and

Latino communities by allocating most of its resources to the north side and the lakeshore. The case was settled a year later, when the Park District agreed to a court order to spend more money in minority, largely low-income neighborhoods. In recent years, as more funds have been directed to parklands on the south and west sides, the agency along with other organizations has been able to spruce up long-neglected natural and architectural features, enhance greenspaces with art and design amenities, and expand cultural and educational programming.

As a result, Chicago's parks are being remade into more attractive, inviting, and user-friendly places. This isn't only a benefit for local community residents; it's a benefit for all current and prospective parkgoers, and believers in the public realm. And it's not just older parks. The soon-to-be-completed Millennium Park downtown and ongoing improvements along the south lakeshore, for example, demonstrate the Park District's commitment to fostering a broadly civic vision of park building that began to be realized more than a century ago.

As Jensen wrote in his 1920 plan, A Greater West Park System (which was never implemented): "We have no right to consider ourselves civilized as long as we permit less fortunate residents of our city to live and multiply in unhealthy surroundings that are devoid of beauty and that are a peril to the whole population, and a menace to the normal development of our civilization. There are those among us for whom the rural influences in the city complex are essential to their very existence. This is well to keep in mind in our future city building, if we desire to prevent from degeneration and eventual extermination some of the sturdiest and noble people who have come to our shore....It is a poor city that drives its people away, and into the suburbs. Both the urbanite and the suburbanite suffer by this transaction. To make the modern city livable is the task of our times."

It would seem that the task of making our cities – and this city, with its unsurpassed parks – more livable, and less like the suburbs, would not be asking too much. But as cities like Chicago continue to proliferate with suburban-style development, as agricultural and open lands – residual wetlands and prairies – out in the suburban fringe continue to subdivide and sprawl, the task of restoring and reclaiming, of creating and re-creating, public lands and urban parks becomes an ever more urgent mandate.

"It's come full circle," Frank Dina observes. "When these parks were originally made, they were for people to get a piece of the country in the city – to have a wetlands experience, for example. It was such a big ordeal for many people to travel to outlying areas because of the lack of cars and public transportation. But now Chicago, like most urban areas, is so sprawling, and rural areas are so built over, that you almost have to take a four-hour drive to find the same kinds of wetlands. It's ironic that Chicago's magnificent parks have, in a sense, become important again because their function is close to the landscape architects' original intent – now you can come here and see what wetlands used to look like."

Dina's photographs capture places at specific points in space and time: parks, after all, present scenes that are both fixed and in flux; they are subjective landscapes, as essayist Szarkowski writes in Viewing Olmsted, "that we complete by entering into them – in the first case physically, and in the second, imaginatively." Parks will be interpreted differently by different artists and documentarians – indeed, by anyone who enters them. The challenge, says Szarkowski, is "to make photographs – little pictures on paper – that would describe how the place looked." It is that elusive goal for which Dina is aiming. We will see the pictures that his eyes and lens sees, and then we will see them for ourselves.

Above all, I believe, Dina is aiming for something else: his body of work, as a socially conscious statement, makes an elegantly understated plea to ensure that parks remain essential features of a civilized, democratic life; to preserve an authentic urbanity that is rapidly vanishing in the face of development and commodification and privatized space; and, to remind us that, although our historic public parklands are idealized, cultivated places, they are real and true places nonetheless, places of nature and culture where we can still discover the soul of a city, and in doing so, rediscover ourselves. ■

*This book is dedicated
to the memory of my father,
Frank A. Dina,
who loved and enjoyed
Chicago's Parks his entire life.*

Sherman Park

Sherman Park, located at 55th and Racine Avenue, is perhaps the finest example of a series of small parks proposed by the South Park Commission at the turn of the century. The Commission retained the Olmsted Brothers firm (the sons of famed naturalistic landscape architect Frederick Law Olmsted) and D.H. Burnham & Co. to design the 60-acre park in 1904-05. Its tranquil, pastoral setting is dominated by an island surrounded by a large, man-made lagoon. The park was named for John Sherman (1825-1902), who founded the Chicago Stock Yards and later served as a South Park commissioner.

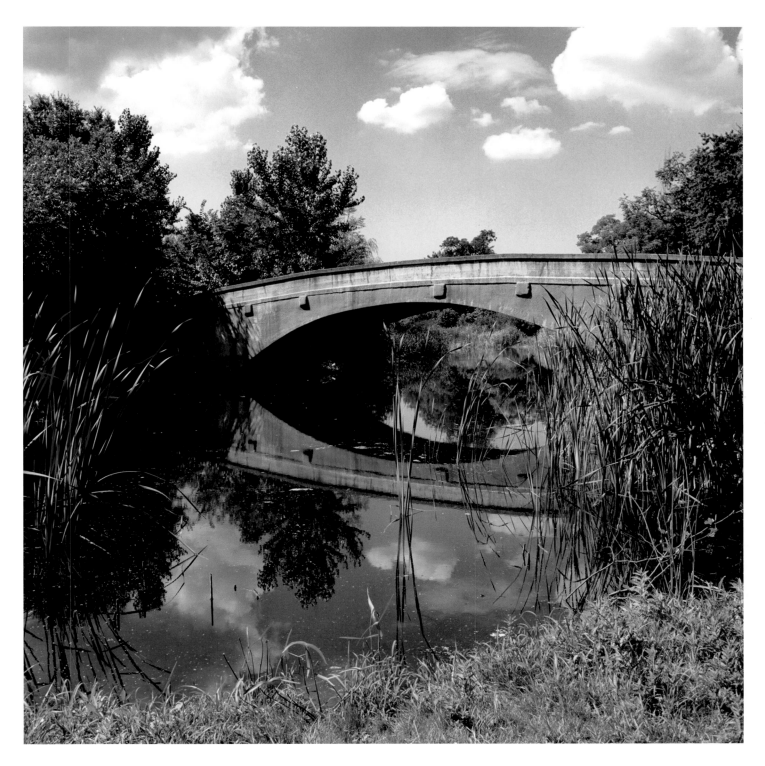

Sherman Park
BRIDGE IN SHERMAN PARK LAGOON

*One of four footbridges connecting parkland
and the lagoon-encircled island.*

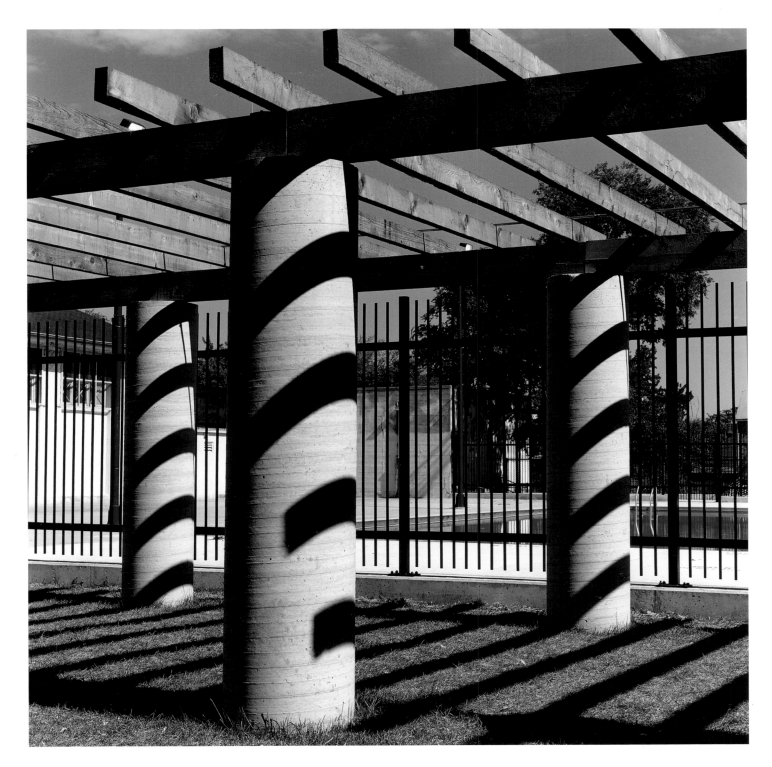

Sherman Park
PERGOLA IN SHERMAN PARK

This pergola is near the swimming pool entrance (a pergola is a covered walkway and arbor consisting of columns that support a lattice roof).

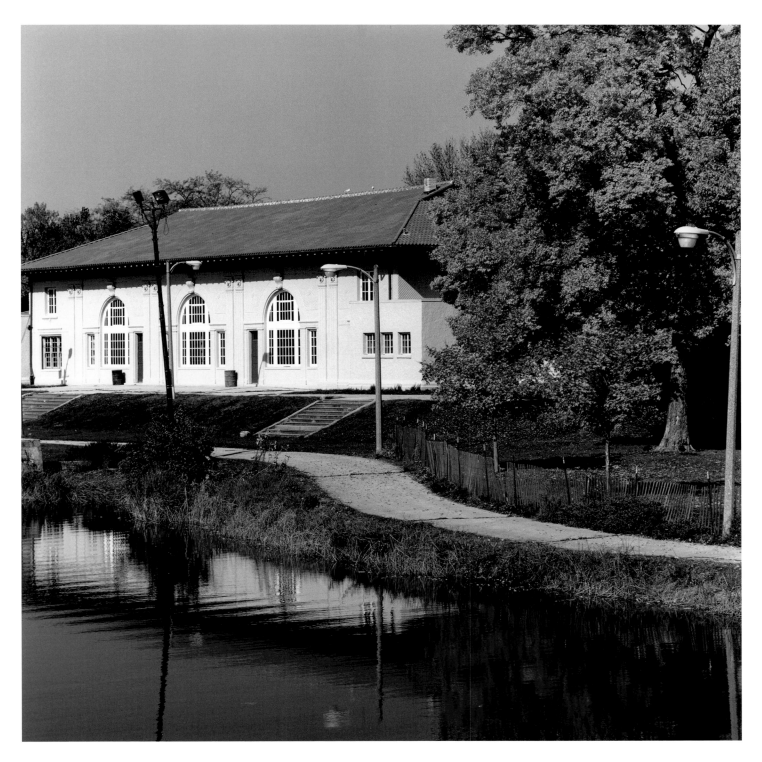

Sherman Park
FIELDHOUSE AND LAGOON

*Daniel Burnham & Co. built this classical
fieldhouse, which contains an auditorium,
a refectory, and meeting rooms.*

Columbus Park

Columbus Park, dating from 1920, was the last major park created for Chicago by Jens Jensen – and his most completely realized expression of the prairie landscape. Formerly a golf course, Jensen was given a clean slate to design the 170-acre park. His design drew from geological history and blended natural and man-made elements into an artful, democratic whole. Jensen hired many of his Prairie School colleagues to design the structures. Located in the west-side Austin neighborhood bordering Oak Park, the park's name was suggested by the Knights of Columbus fraternal organization. Although its southern end was truncated in the 1950s to make way for the Eisenhower Expressway, the Chicago Park District restored many existing features in 1992.

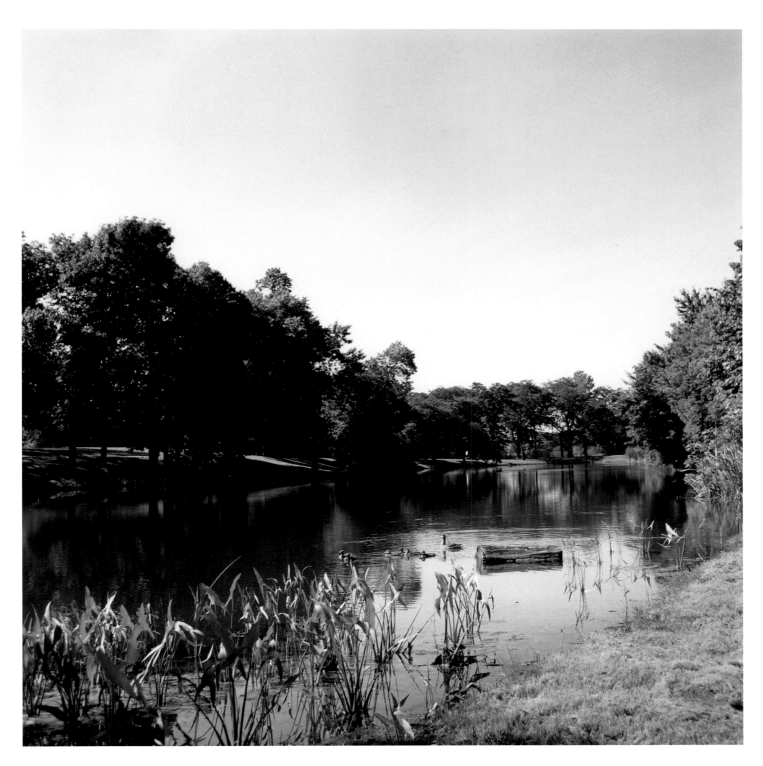

Columbus Park
LAGOON WITH DUCKS

*Jens Jensen was inspired by the native
Illinois landscape to create this "prairie river."*

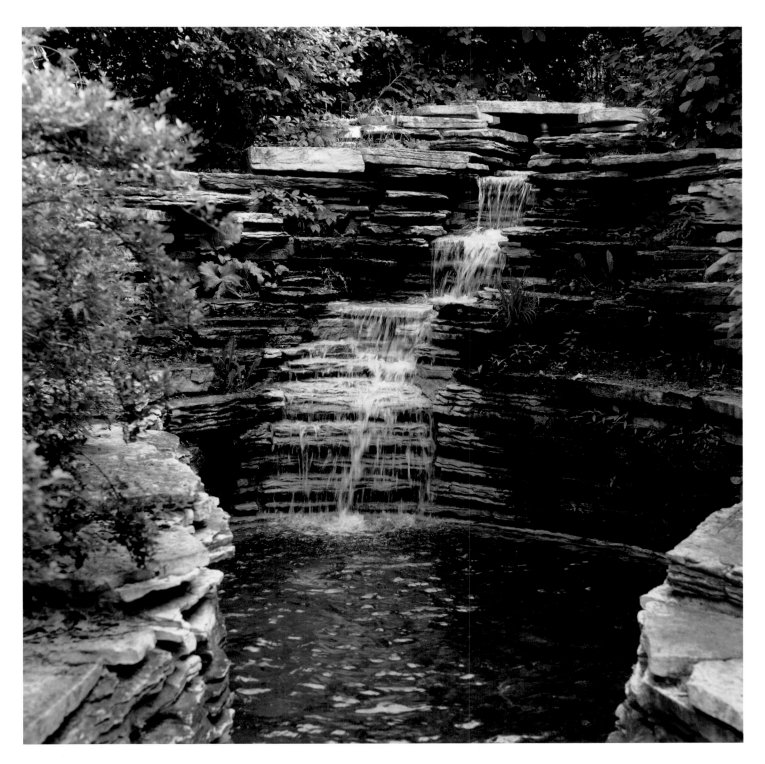

Columbus Park
GROTTO

*This waterfall was built of
stratified stonework to evoke a
rock-ledged Illinois river bluff.*

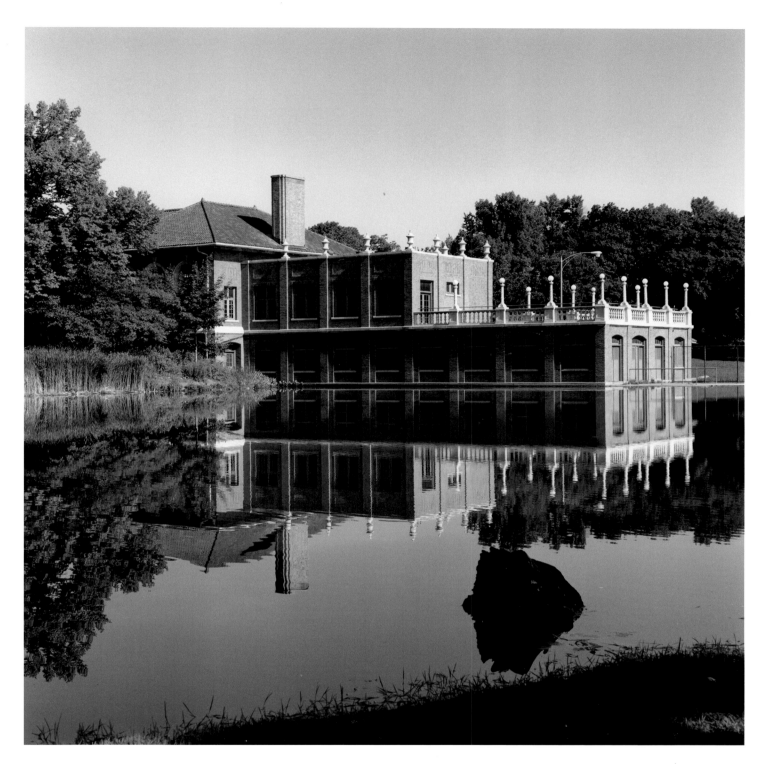

Columbus Park
LAGOON AND REFECTORY

The refectory, designed by Chatten &
Hammond in 1922, and the lagoon each
provide reflective views of the other.

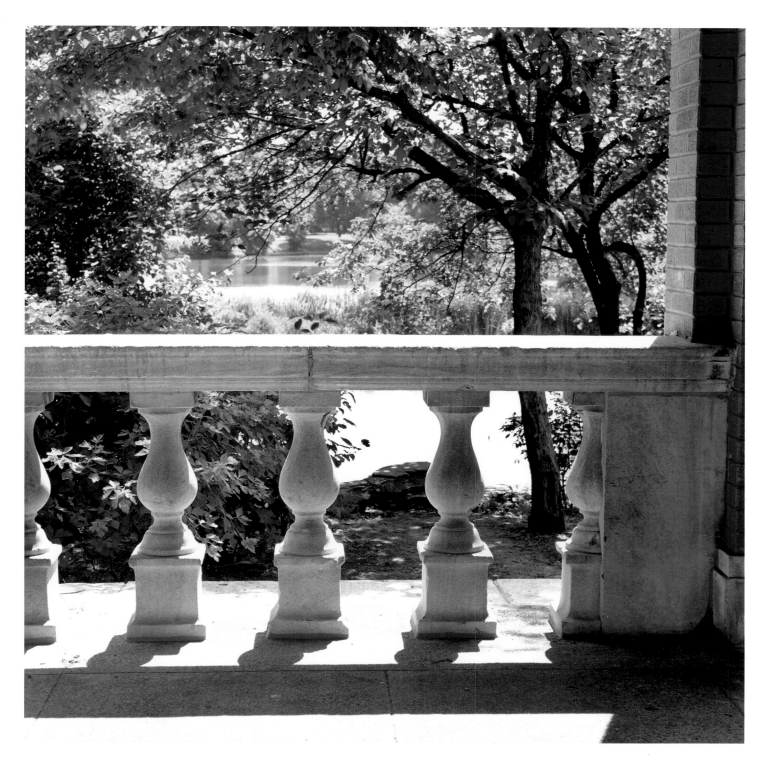

Columbus Park
REFECTORY VIEW

*Looking out onto the prairie
lagoon from a refectory portico.*

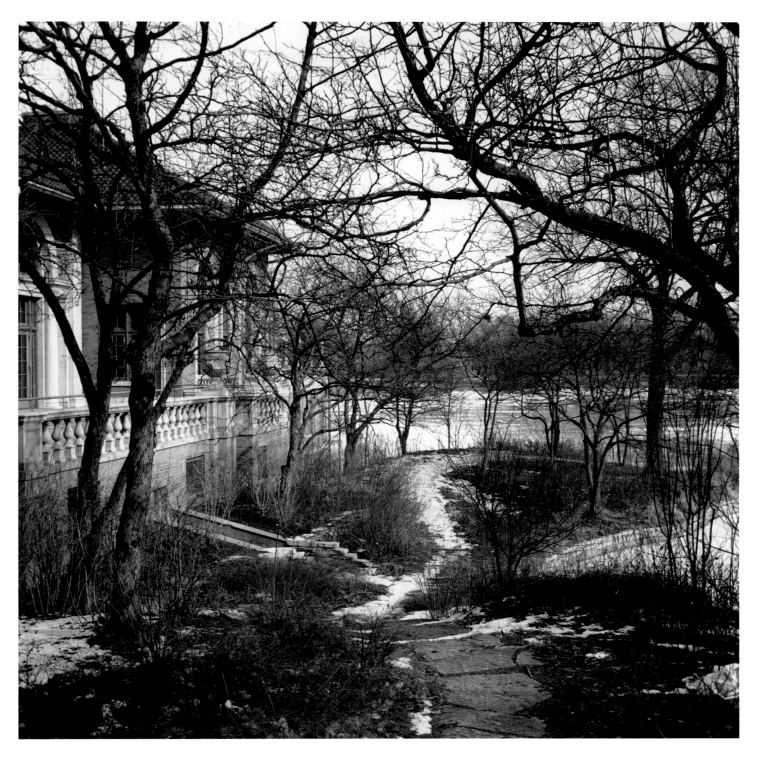

Columbus Park
REFECTORY IN WINTER

Snowy paths surround the refectory,
which was restored in 1992.

Humboldt Park

Humboldt Park is perhaps the most naturalistically picturesque of Chicago's three great 19th-century West Side parks (along with Garfield and Douglas). In 1871 William Le Baron Jenney was hired as chief engineer for the park system and its connecting boulevards. He designed what was then called Upper Park, later renamed for Alexander von Humboldt (1769-1859), the famous German explorer and scientist. The creation of the 210-acre park, along with the Chicago Fire of 1871, spurred real estate speculation in the area, which, at the time, was beyond the city limits. When Jens Jensen became general superintendent and chief landscape architect of the 585-acre West Park System in 1905, he developed his first, full-scale "prairie river" landscape in Humboldt Park.

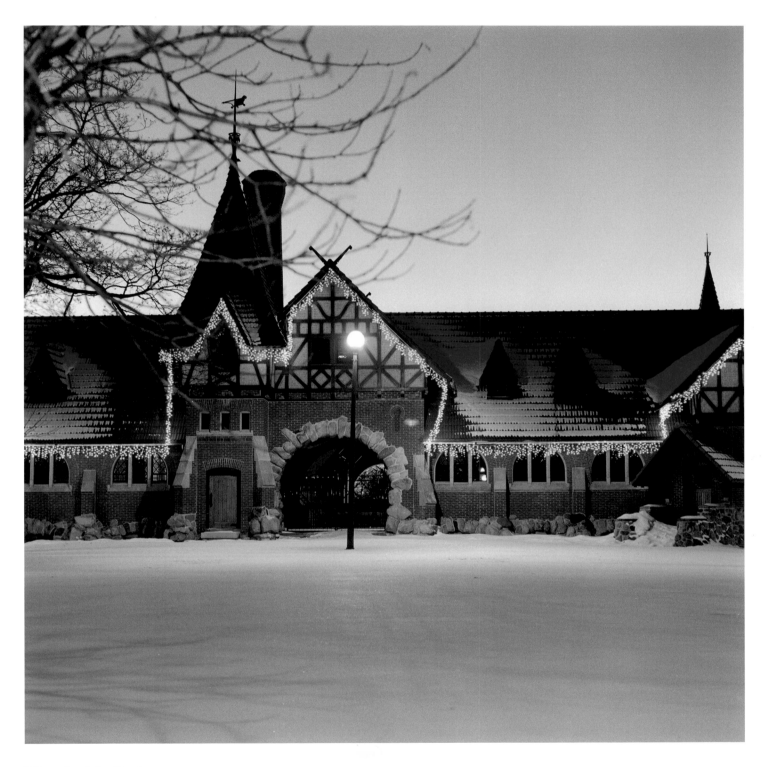

Humboldt Park
HUMBOLDT PARK STABLES – WINTER EVENING

*Following a disastrous fire in 1992, this
structure was restored several years later to
become a community cultural center.*

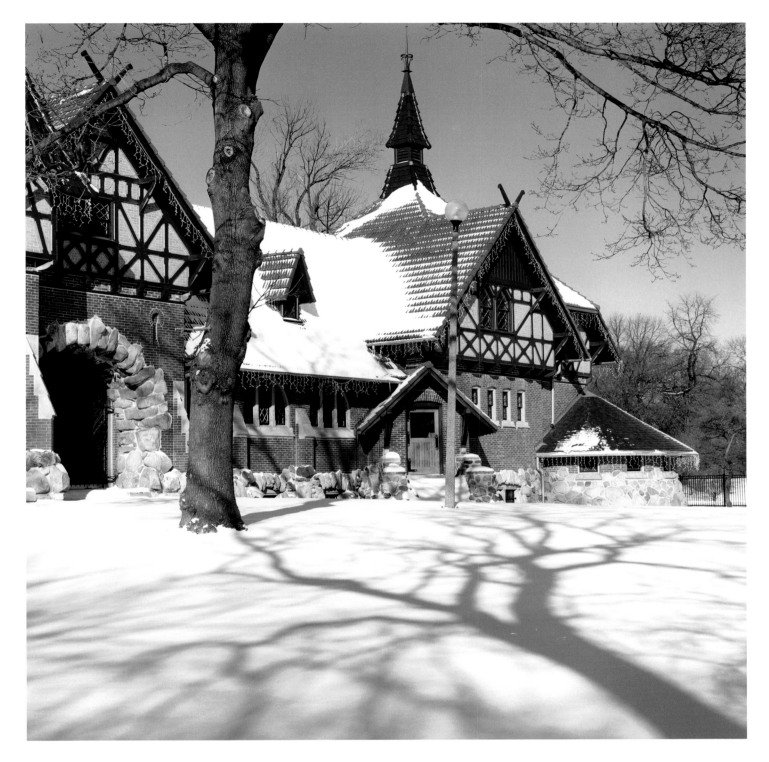

Humboldt Park
HUMBOLDT PARK STABLES – WINTER

*Frommann & Jebson designed the Receptory
& Stables building in 1896 in the style of old
German country-house architecture.*

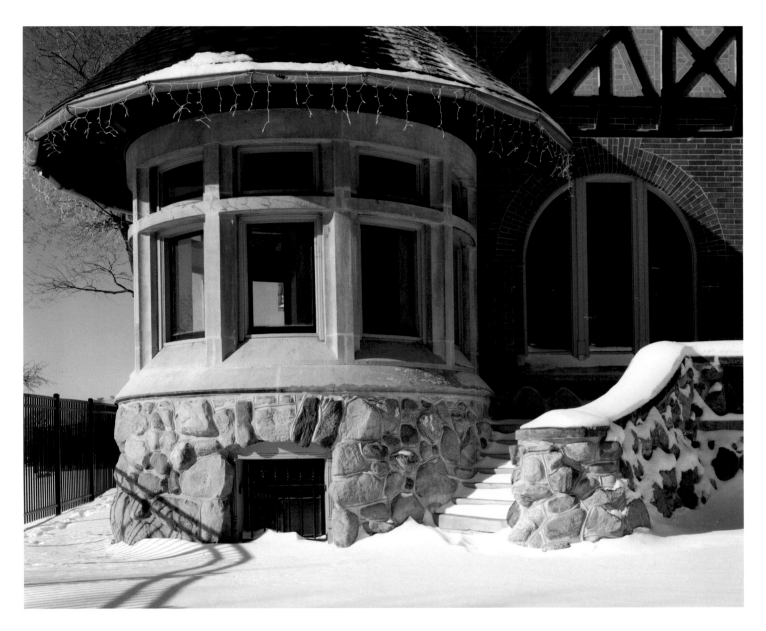

Humboldt Park
HUMBOLDT PARK STABLES DETAIL

Jens Jensen had his office in this building when he was park superintendent from 1896 to 1900.

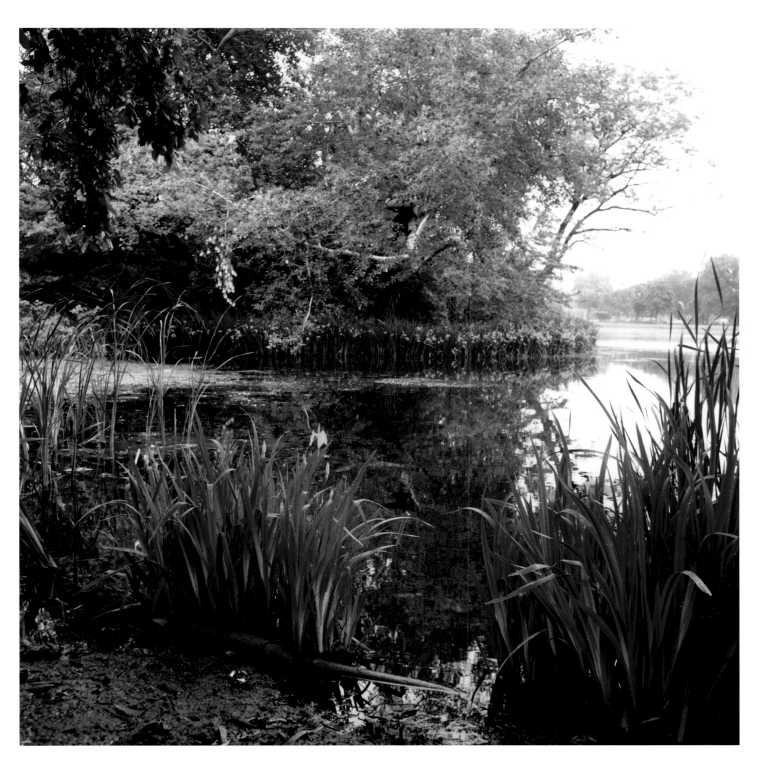

Humboldt Park
HUMBOLDT PARK LAGOON

The lagoon offers many vistas typifying the "picturesque ideal" of naturalistic park design.

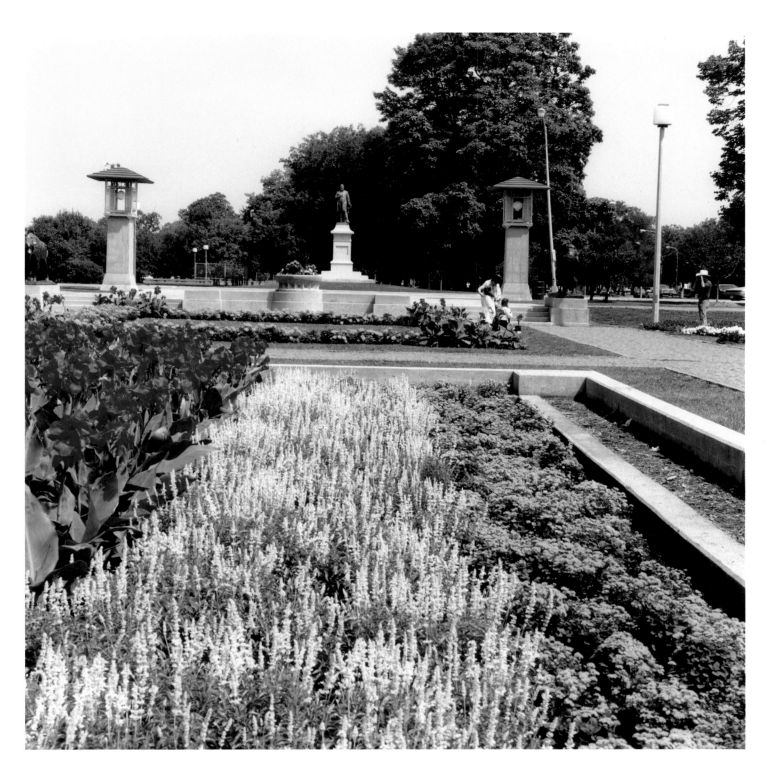

Humboldt Park
HUMBOLDT PARK ROSE GARDEN

The Rose Garden was designed by Jens Jensen in 1907 and is one of his few formal garden designs for a public park.

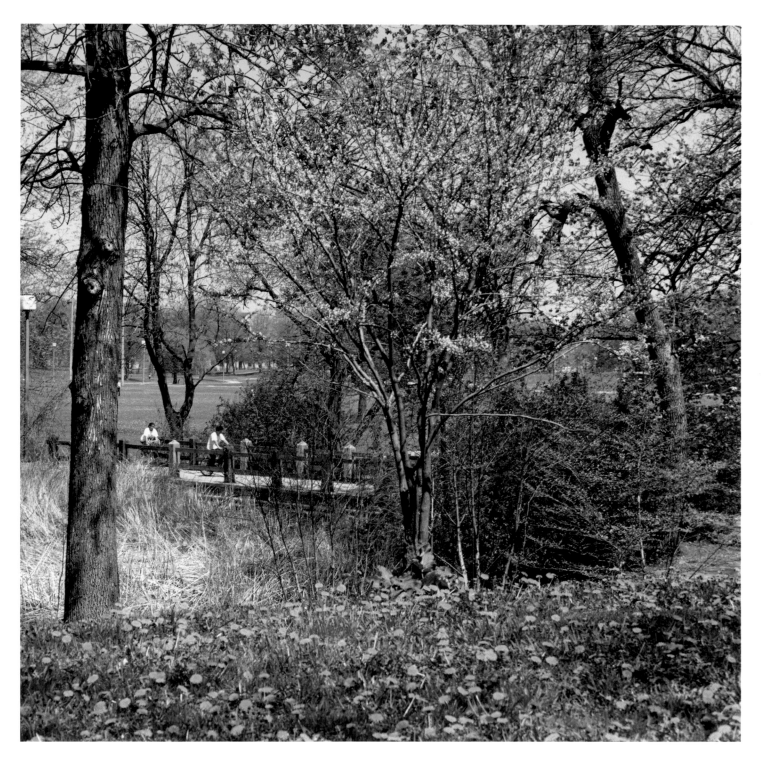

Humboldt Park
Spring in Humboldt Park

Many paths wind over bridges
around the ponds and lagoon.

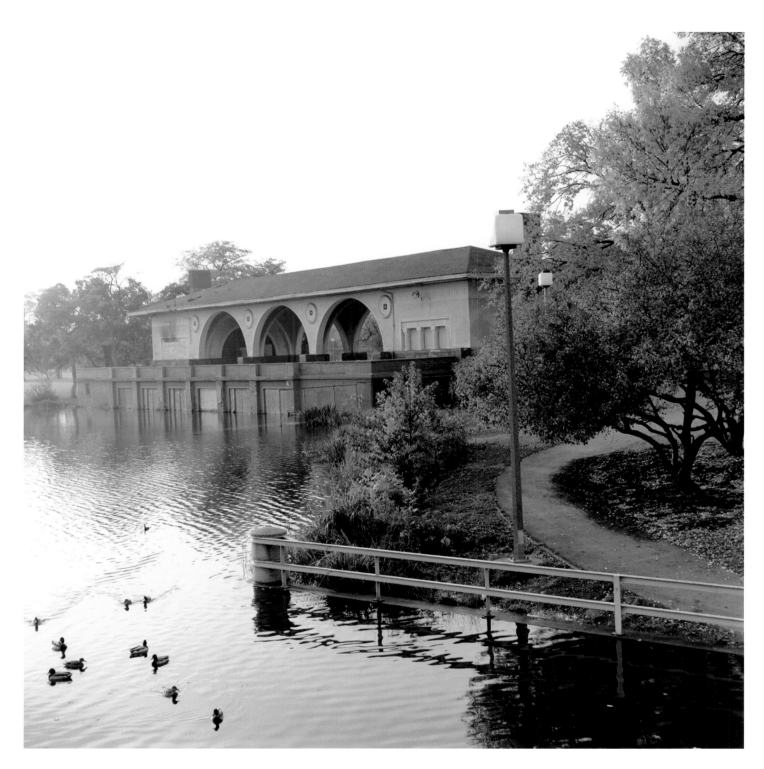

Humboldt Park
HUMBOLDT PARK BOATHOUSE

*The refectory and boat landing, a
Prairie School masterwork, was designed
by Schmidt, Garden & Martin in 1907.*

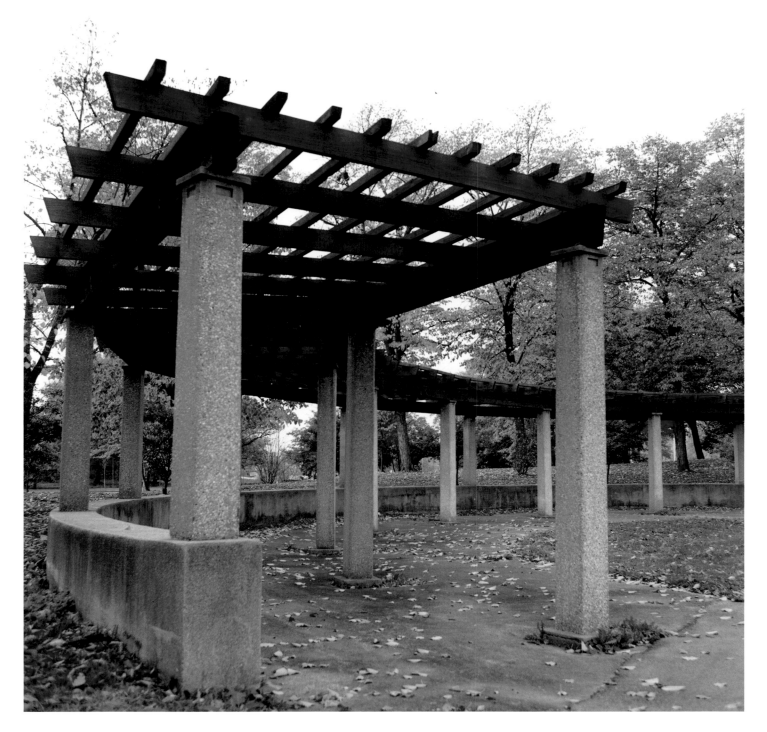

Humboldt Park
PERGOLA – FALL

*Semicircular pergolas surround
Jens Jensen's formal flower garden.*

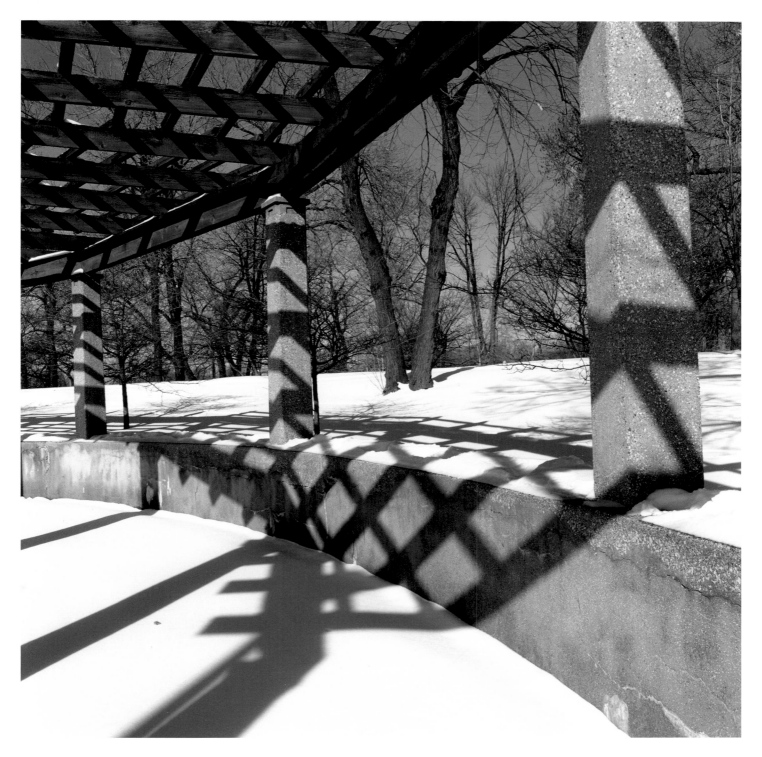

Humboldt Park
Pergola Shadows

*The pergolas provide a visual contrast
to their natural surroundings.*

Grant Park

Grant Park, which forms Chicago's "front yard," was created from landfill and 1871 Chicago Fire debris. The site's origins as an open space date to the 1830s when Illinois & Michigan Canal commissioners platted the town and set aside a spot on their map for a "Public Ground – A Common to Remain Forever Open, Clear and Free of any Buildings, or Other Obstructions whatever." Lake Park (as it was originally known) was officially established in 1847, although it remained unimproved until 1890. The South Park Commission took control of the site in 1896, renamed it Grant Park in 1901 (after U.S. President Ulysses Grant), and two years later commissioned the Olmsted Brothers to create a formal design fashioned after the gardens of Versailles with a series of symmetrical "rooms." Plans were implemented under the direction of Edward Bennett – co-author with Daniel Burnham of the 1909 Plan of Chicago – between 1915 and 1930. The park is home to many of Chicago's cultural treasures, including the Art Institute, the Buckingham Fountain, the Field Museum, the Shedd Aquarium, and the new Millennium Park (which is officially scheduled to be completed, with all its amenities, in the summer of 2003), and it is also the site of numerous summer festivals. While Grant Park boasts an outstanding collection of commemorative statuary, it lacks one thing: the statue of the man whose name it bears. Strangely enough, a statue of Grant is in Lincoln Park.

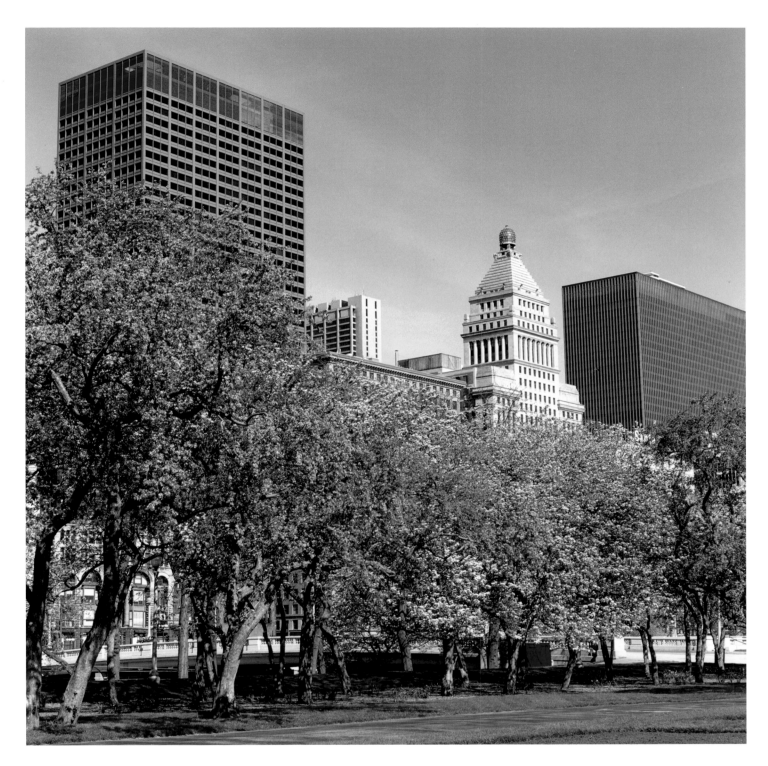

Grant Park
GRANT PARK WALKWAY

*Those wishing to see a "city in a garden" can
do no better than to stroll through Grant Park.*

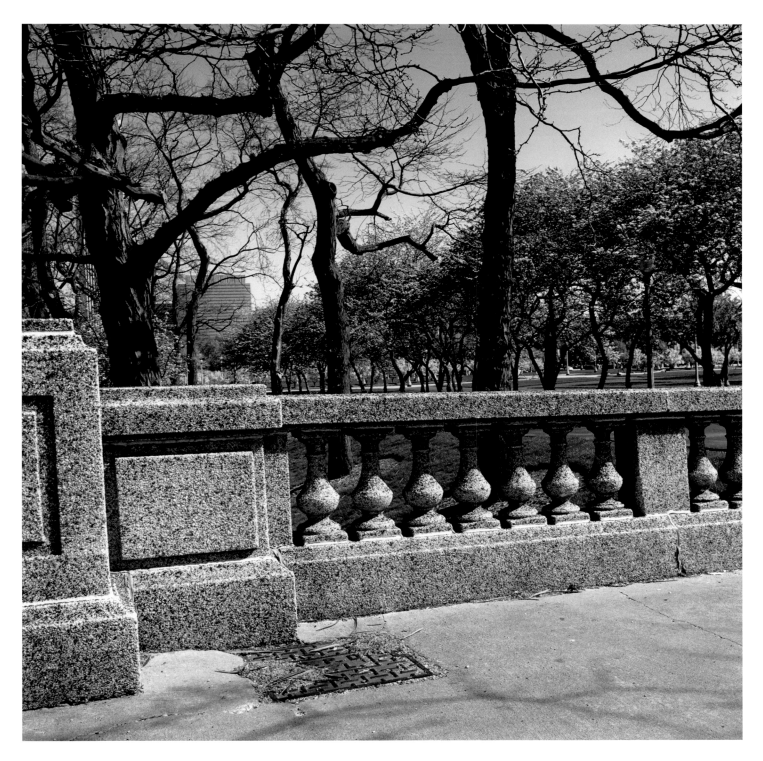

Grant Park
GRANT PARK BRIDGE

*One of several bridges that span the
Illinois Central railroad tracks that have
been in place since the 1850s.*

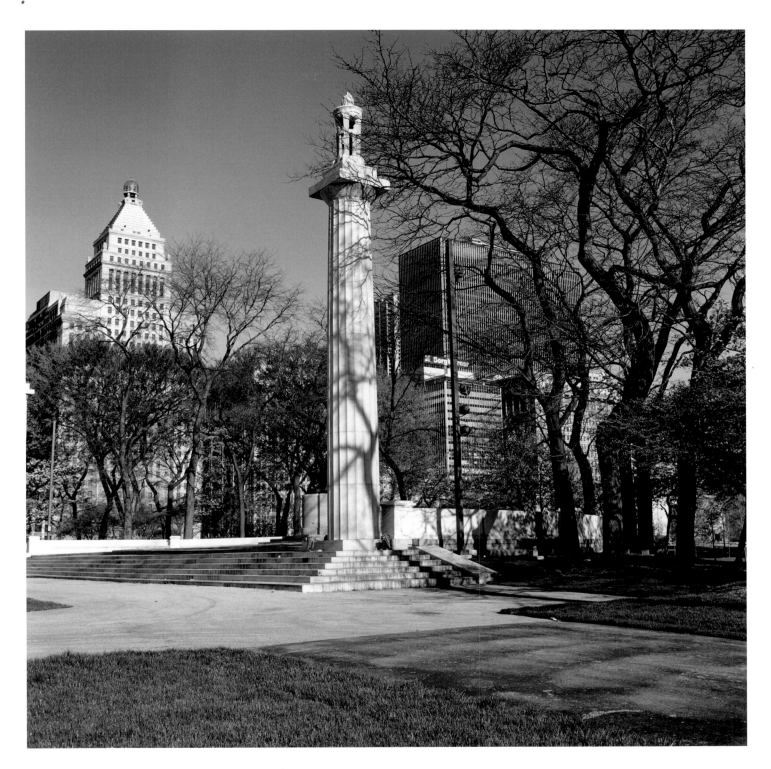

Grant Park
LINCOLN MONUMENT

*Fluted columns are adjacent to
"the Seated Lincoln," a sculpture
by Augustus Saint-Gaudens.*

Lincoln Park

Lincoln Park, at 1,212 acres, is Chicago's largest and most popular park, extending nearly six miles along the city's beautiful lakefront from Oak Street to Ardmore Avenue. It is also among the city's oldest parks, and over the decades improvements have included renowned works of art, landscape design, and architecture. The park's many special features have also been shaped by increased recreational needs. Its southern section was originally the municipal cemetery, but as the population of the surrounding neighborhood grew, an unused part of the burial ground was reserved as Lake Park in 1860. In 1865 – when the park was renamed for the recently assassinated president, Abraham Lincoln – gardener Swain Nelson laid out the first plan, drawing from French landscaping traditions. Structures began to be built in the 1880s, when the park was among the city's premier tourist attractions. In later years, the park was modified and expanded by such designers as Ossian C. Simonds, Ernest G. Schroeder, and Alfred Caldwell using midwestern-style naturalistic landscaping.

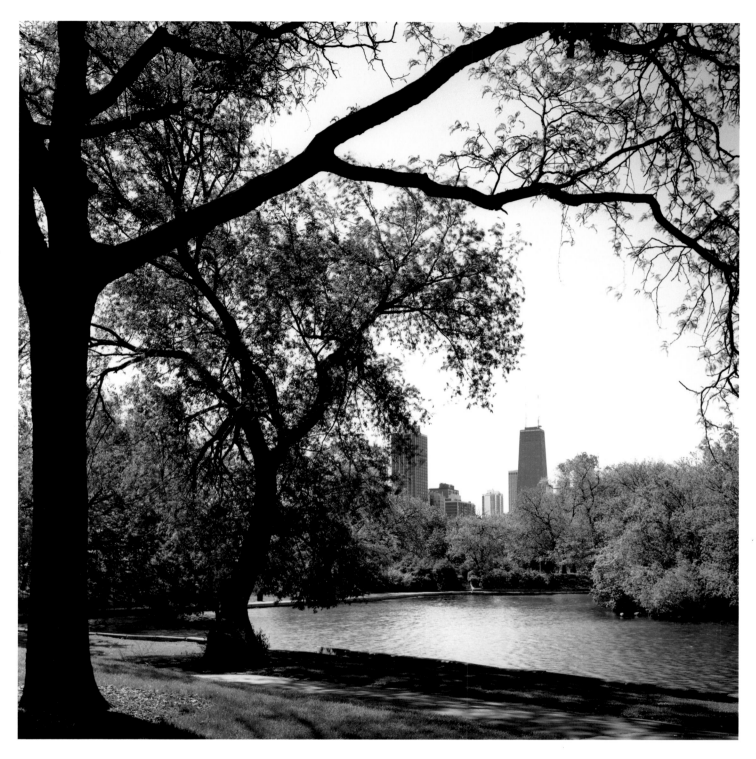

Lincoln Park
LINCOLN PARK LAGOON

*A view of the Chicago skyline
from across the South Pond.*

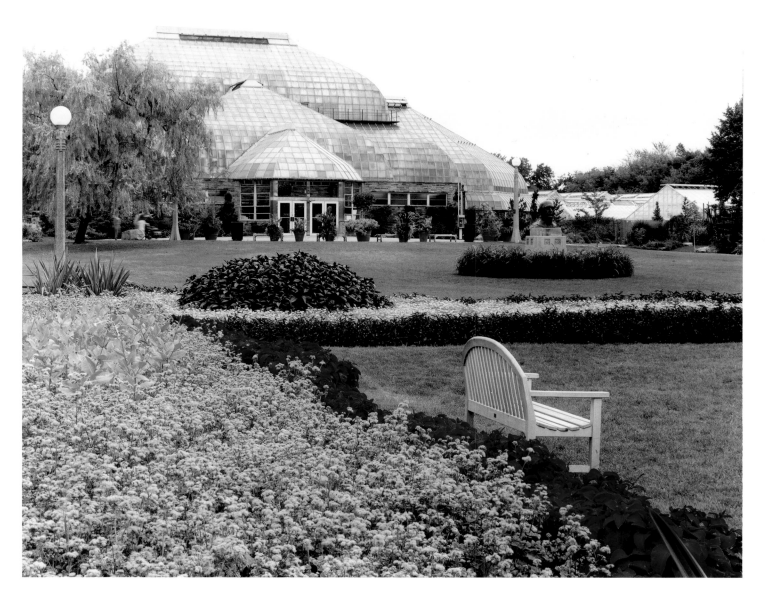

Lincoln Park
FLOWER GARDEN AND CONSERVATORY

*The Lincoln Park Conservatory was originally
built in 1894 by Joseph Lyman Silsbee and overlooks
a formal French garden dating from 1887.*

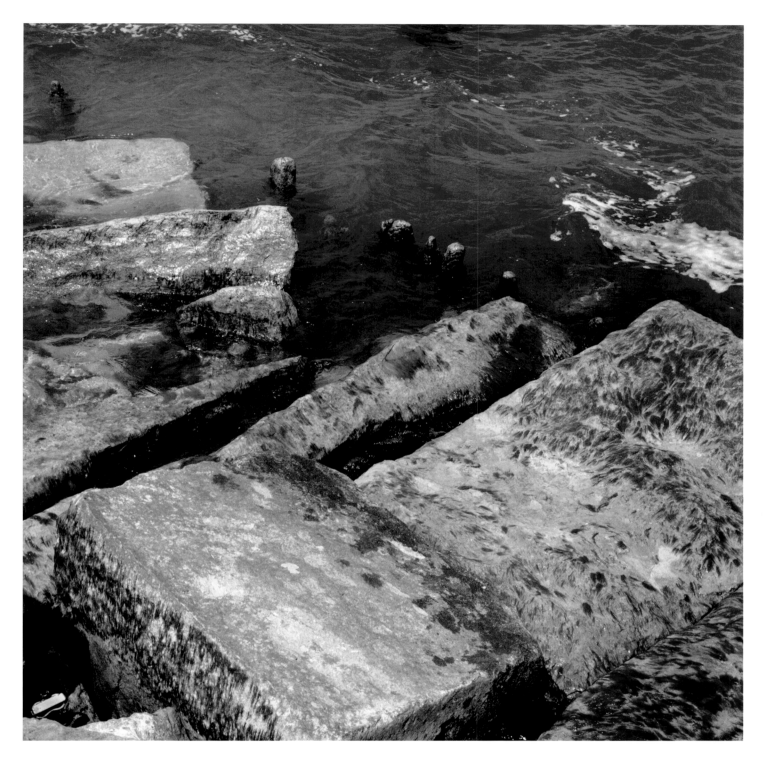

Lincoln Park
Montrose Rocks

Rocks and breakwaters form unexpected patterns along the shoreline.

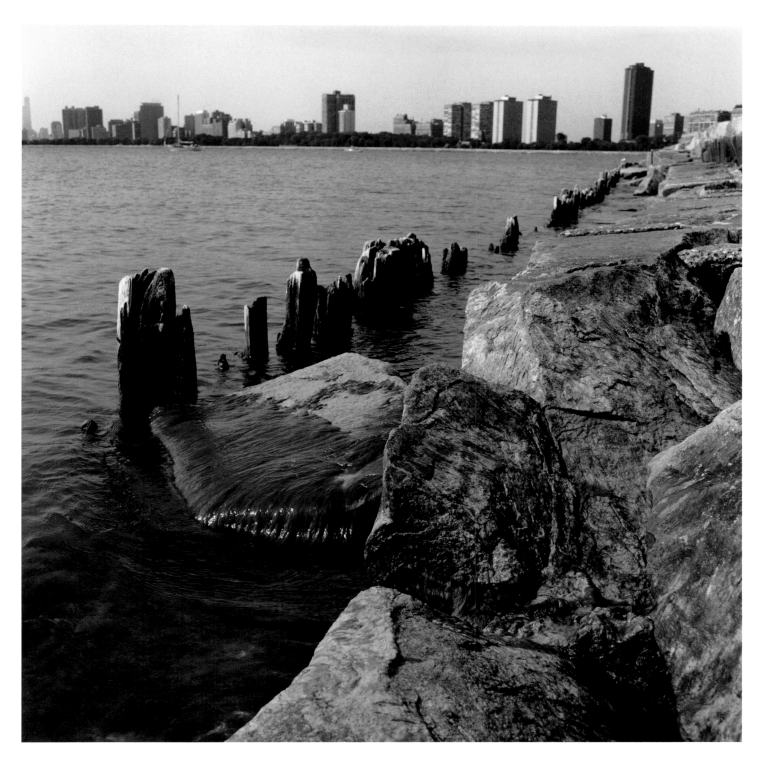

Lincoln Park
MOSSY ROCKS

To help prevent erosion, limestone slabs
shore up the lakefront from Montrose Harbor
to Belmont Harbor, about 1 1/2 miles.

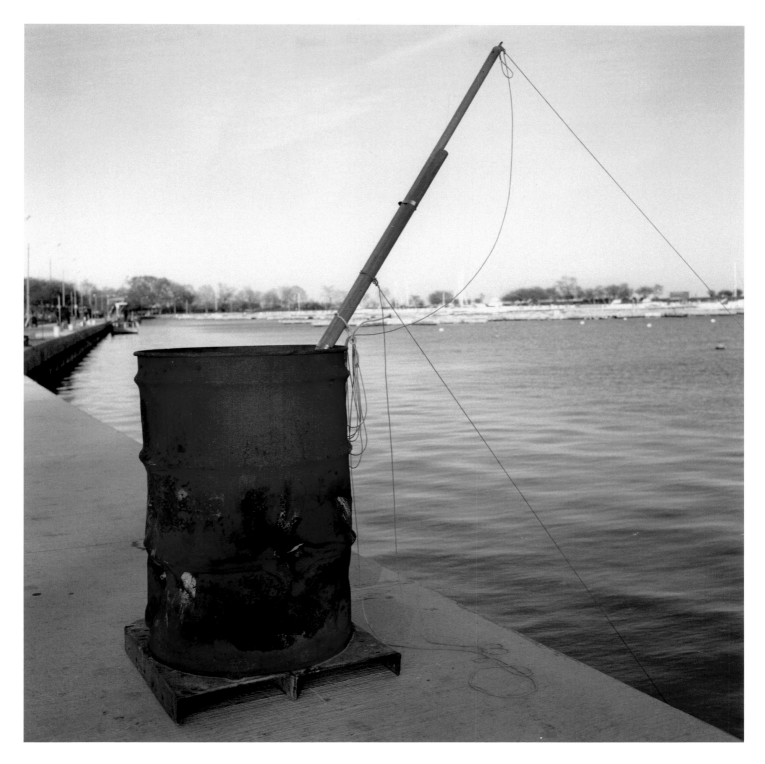

Lincoln Park
SMELT FISHING IN MONTROSE HARBOR

In early spring, the lakefront fills with
smelt fishermen, some of whom find
creative ways to support their nets.

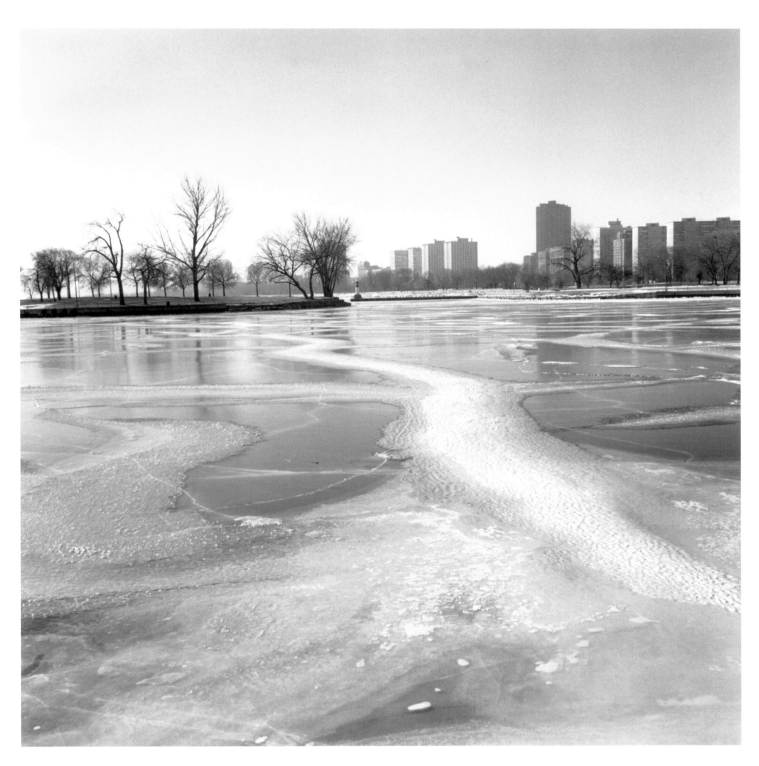

Lincoln Park
ICE IN MONTROSE HARBOR

*Unlike the lake, Chicago's harbors
often freeze over in the winter,
forming sinuous patterns of ice.*

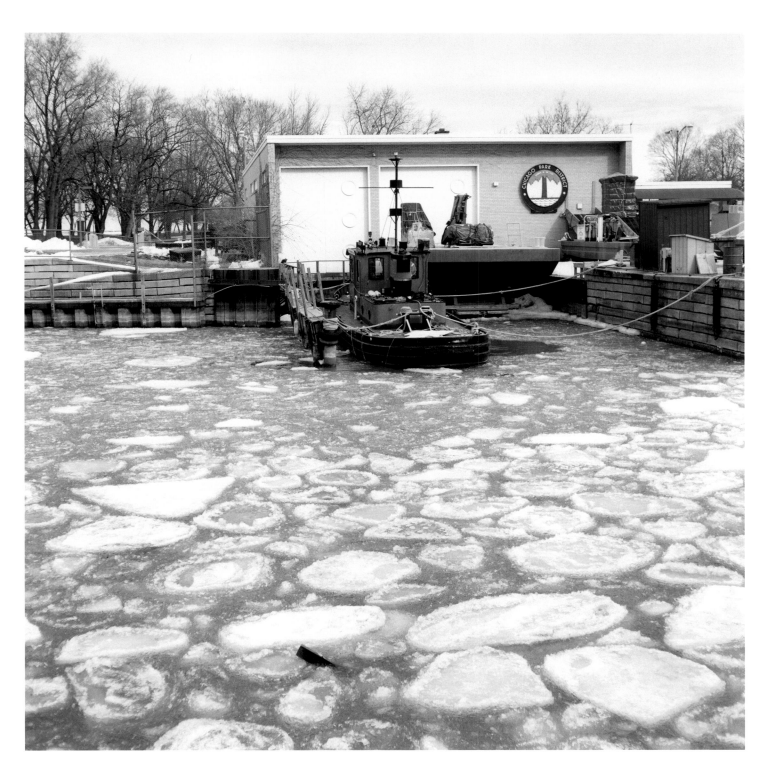

Lincoln Park
TUGBOAT IN BELMONT HARBOR

With pleasure crafts gone, only sturdy tugboats brave the harsh winter.

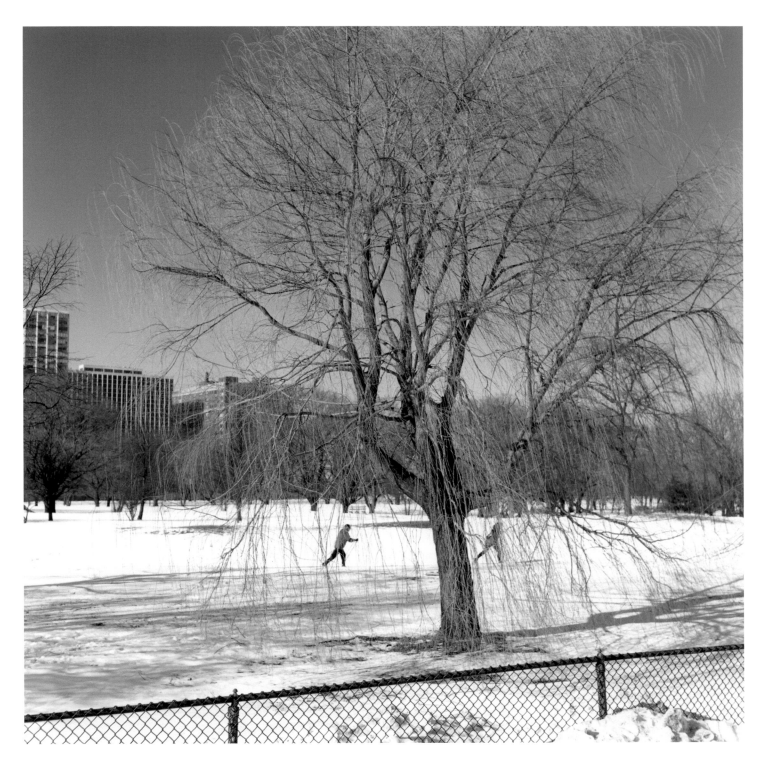

Lincoln Park
MAROVITZ GOLF COURSE – WINTER

*Cross-country skiers find another
way to enjoy the playing green.*

Douglas Park

Douglas Park is the southernmost of the three great West Side parks, along with Garfield and Humboldt. Like them, Douglas was created by William Le Baron Jenney beginning in 1871 and improved by Oscar DuBuis in the 1880s and Jens Jensen in the 1900s. Jenney brought the land to grade level by filling it with manure from the Chicago Stock Yards; elements of his naturalistic landscape design survive in the northern lagoon area. Jensen's Prairie-style influence can still be seen in the southern portion below Ogden Avenue, where he drained a shallow pond to create a large meadow. This part of the park also includes the 1907 Flower Hall (a covered walkway), a lily pond, and a formal garden. The 173-acre park, which lies in the North Lawndale neighborhood, was named for Stephen Douglas, the pre-Civil War political leader.

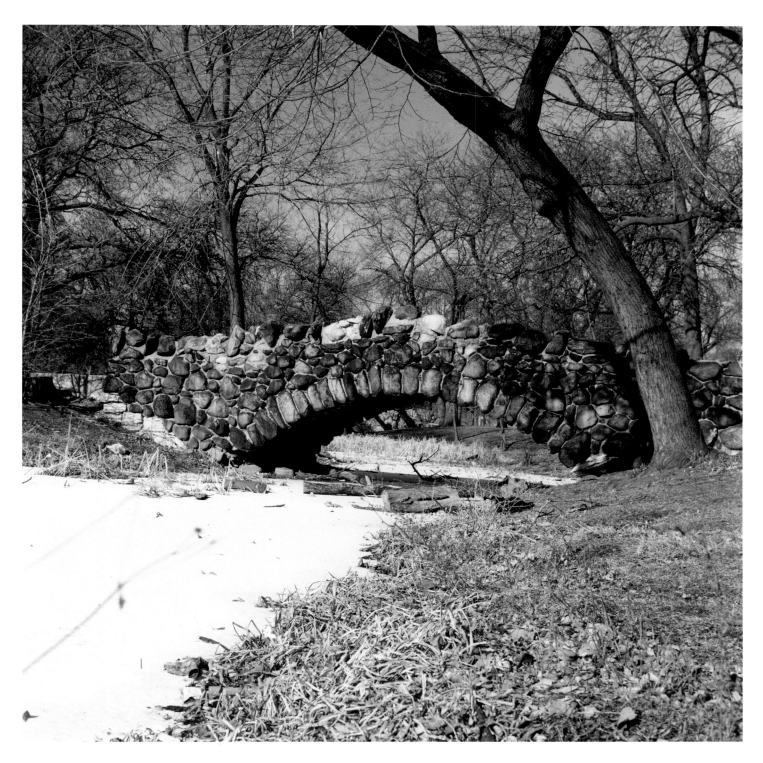

Douglas Park
STONE BRIDGE IN DOUGLAS PARK

*The Stone Bridge, built in 1897, is one of the
few surviving vintage structures in this park
originally laid out by William Le Baron Jenney.*

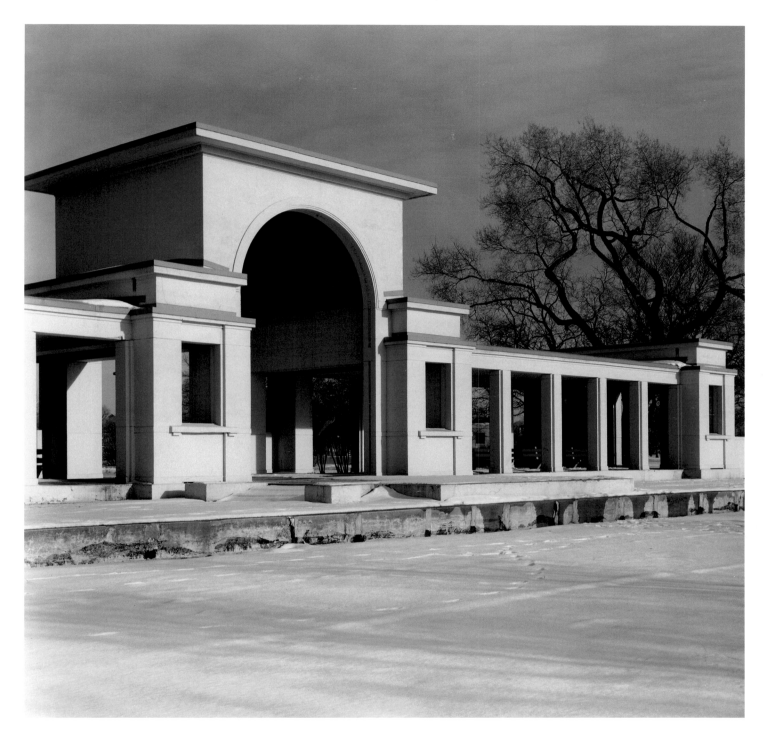

Douglas Park
Flower Hall in Winter

This reinforced-concrete covered walkway was designed around 1907 and combines Prairie School and Classical elements.

Garfield Park

Garfield Park was the middle of the West Park System's three great parks. Originally called Central Park, it was renamed following the assassination of President James Garfield in 1881. Like Humboldt and Douglas parks, the 184-acre pleasure ground was laid out by William Le Baron Jenney in the early 1870s, modified by Oscar F. Dubuis in the 1890s, and enhanced by Jens Jensen in the early decades of the 20th century. As at Humboldt Park, Jenney transformed a flat, desolate site into a picturesque space inspired by the naturalistic landscape movement and French parks and gardens. Jensen also brought Prairie School architecture into the park, including the world-famous conservatory with its prehistoric prairie gardens. The park, along with improved transportation, led to wealthy and middle-class residential development in the surrounding neighborhood.

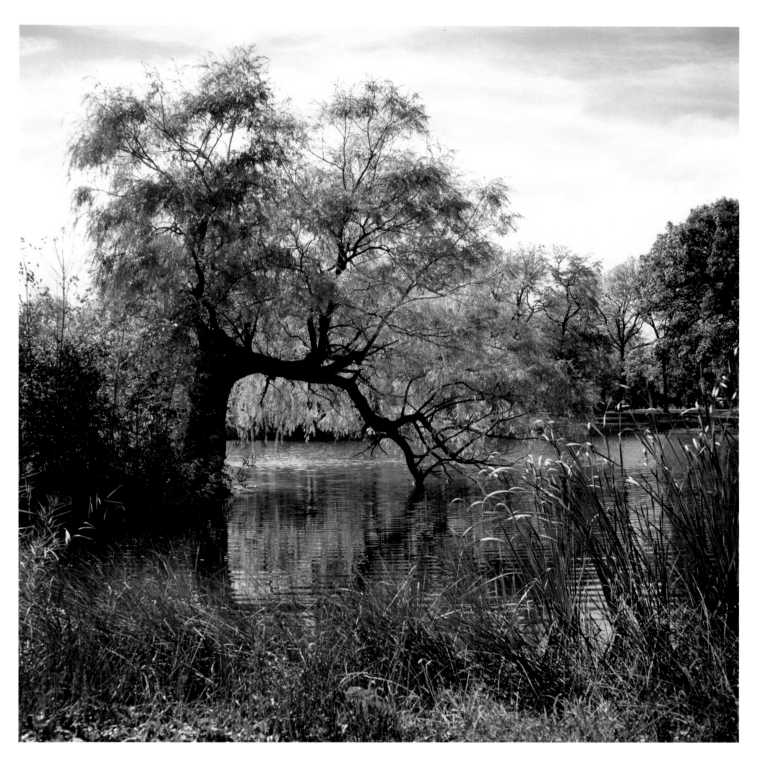

Garfield Park
TREE BY THE LAGOON

*A true "city in a garden," the eastern
lagoon area is believed to be the oldest
preserved landscape in a Chicago park.*

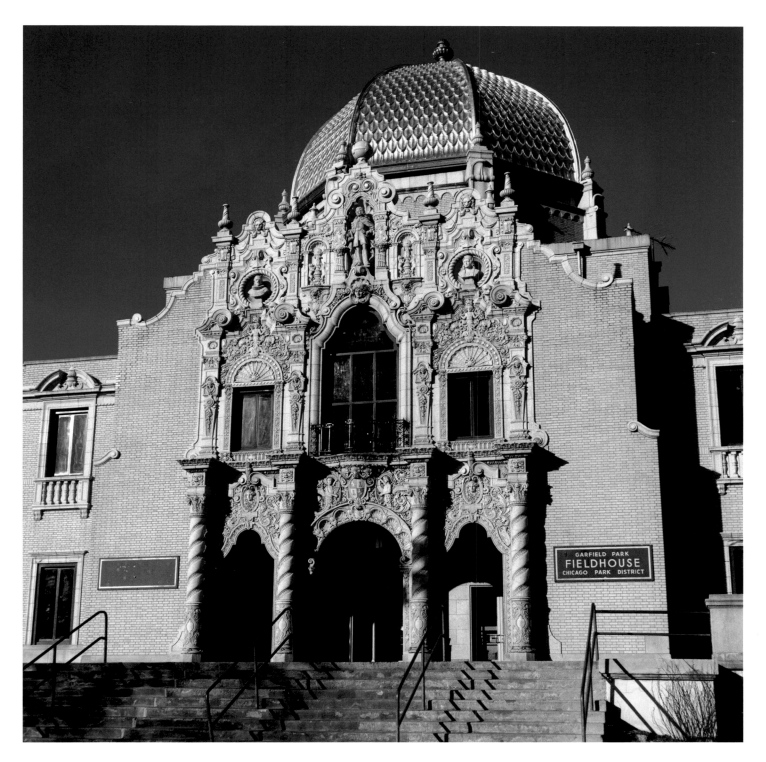

Garfield Park
GOLD DOME BUILDING

*This Spanish Baroque Revival
structure, built in 1928 by Michaelsen
& Rognstad, originally served as the
West Park Commission Building.*

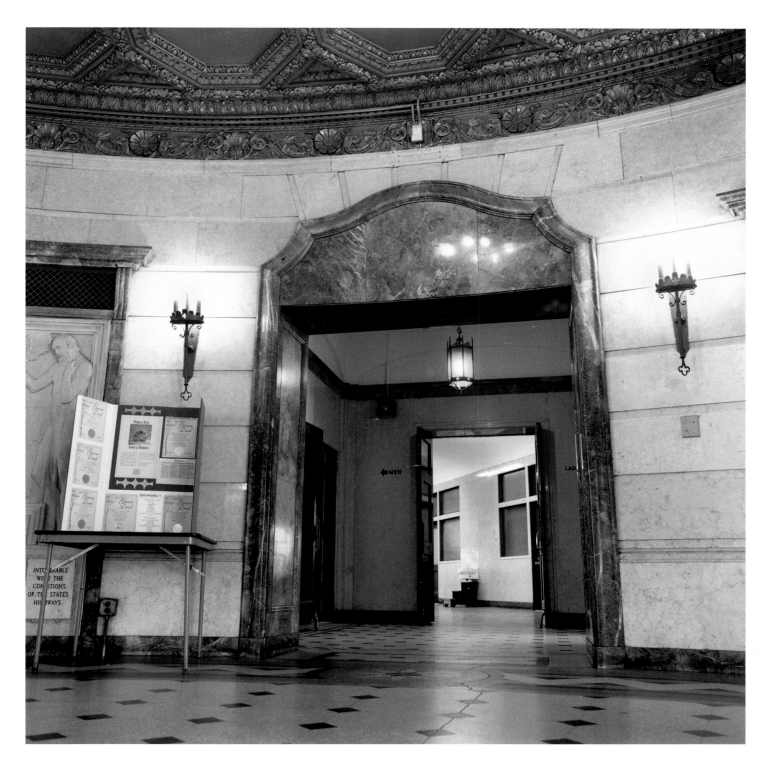

Garfield Park
GOLD DOME BUILDING LOBBY AND HALLWAY

*The facility, with its elegant stonework
and gold ornamentation, became the
park's field house in the 1930s.*

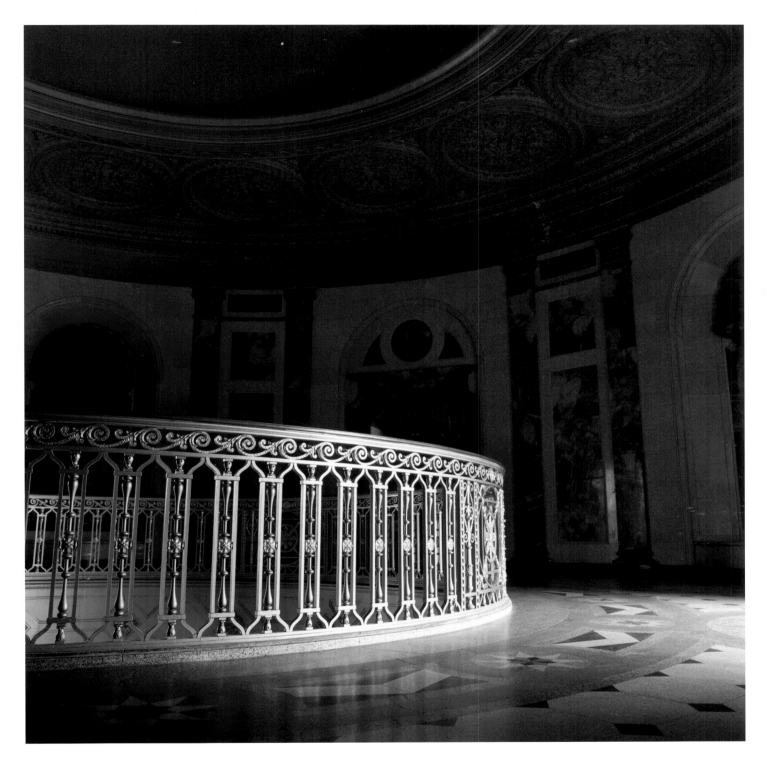

Garfield Park
GOLD DOME BUILDING INTERIOR

*The recently restored gold terra-cotta
dome houses a rotunda with a terrazzo floor
and relief panels by sculptor Richard Bock.*

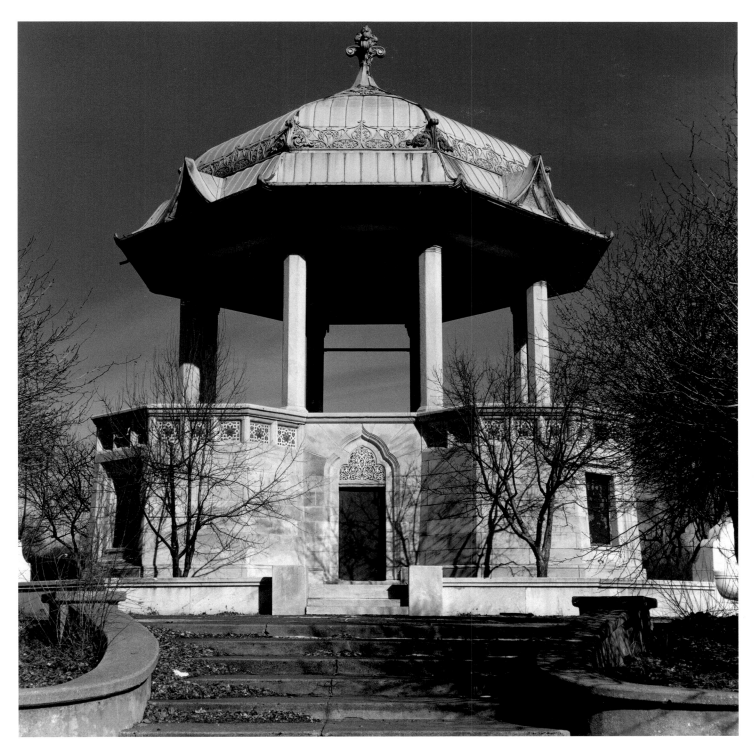

Garfield Park
GARFIELD PARK BANDSHELL

*This marble octagonal structure was
designed by Joseph Lyman Silsbee in 1896
and could accommodate a large orchestra.*

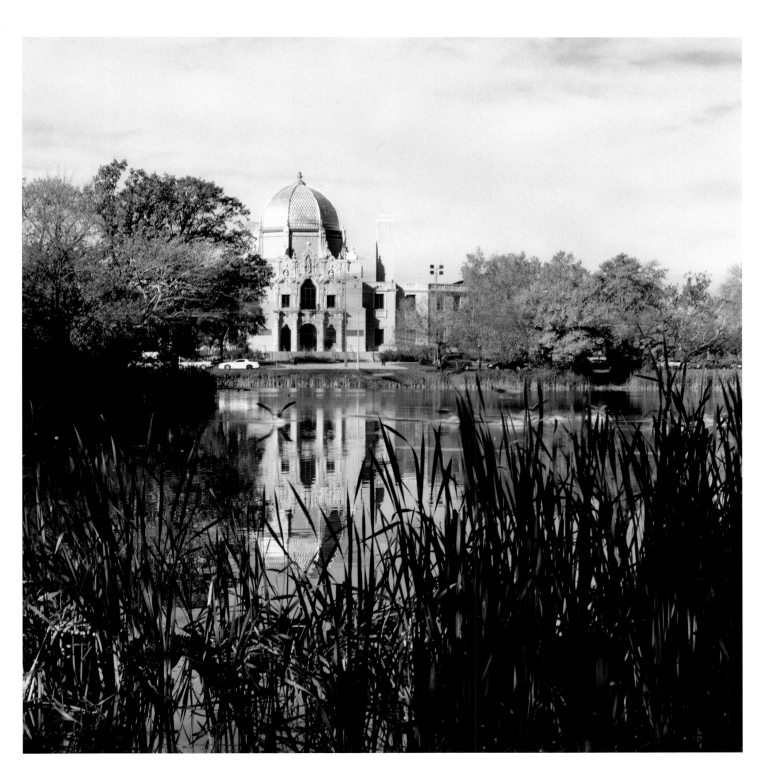

Garfield Park
GOLD DOME BUILDING – FALL

*A view from across the eastern lagoon,
with its Midwestern prairie vegetation.*

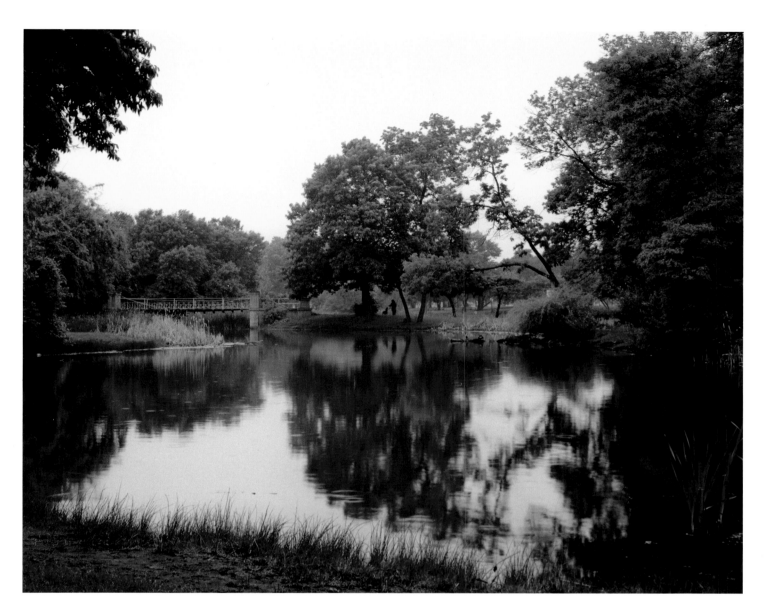

Garfield Park
WOMAN AND DOG AT THE LAGOON

The Garfield Park Lagoon, created by
William Le Baron Jenney in the early 1870s
once teemed with excursion boats.

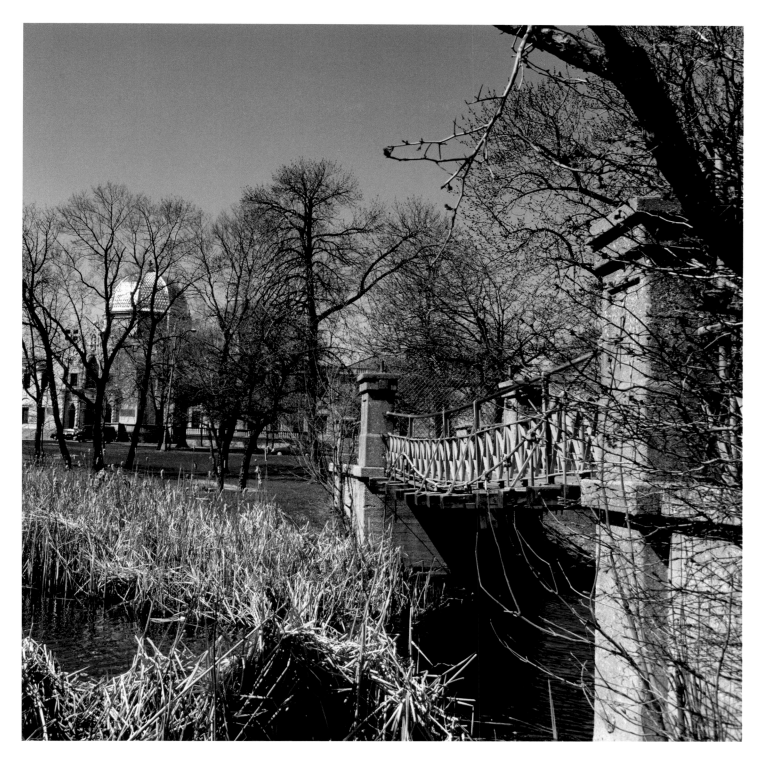

Garfield Park
Bridge in Garfield Park

*William Le Baron Jenney's 1874
Suspension Bridge, among the park's
surviving original elements, predates his
skyscraper-engineering by a decade.*

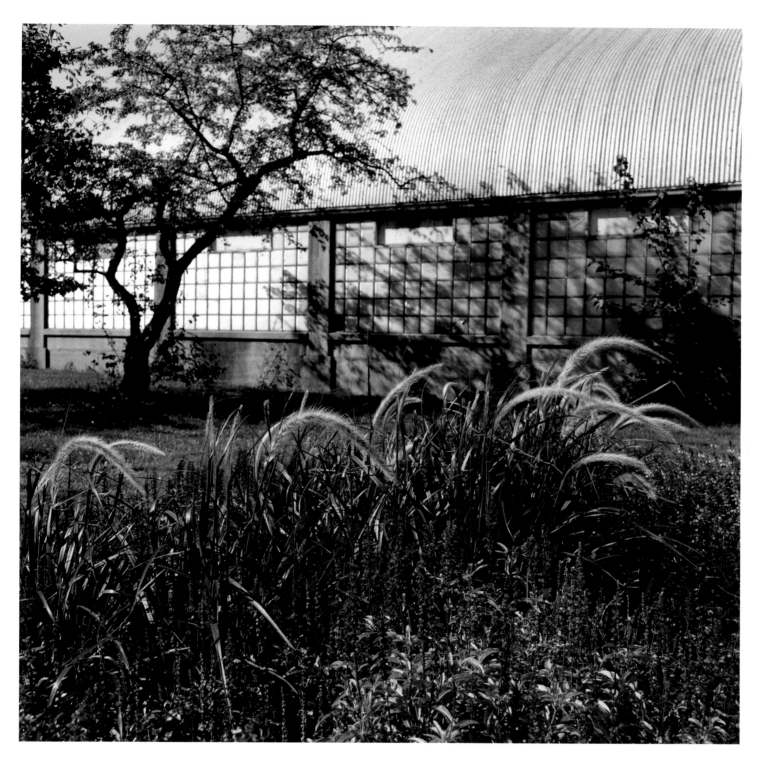

Garfield Park
CONSERVATORY – EXTERIOR

*Gardens bloom outside the
Garfield Park Conservatory, too.*

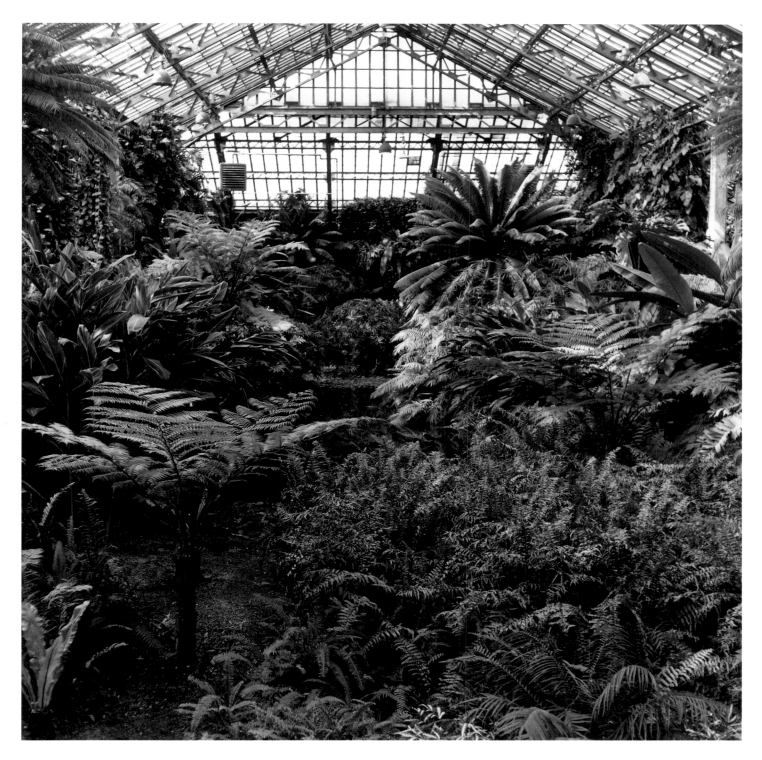

Garfield Park
FERN ROOM

Featuring a small lagoon and stratified stonework, this room is the centerpiece of the conservatory, designed by Jens Jensen, Hugh Garden, and others in 1906-07.

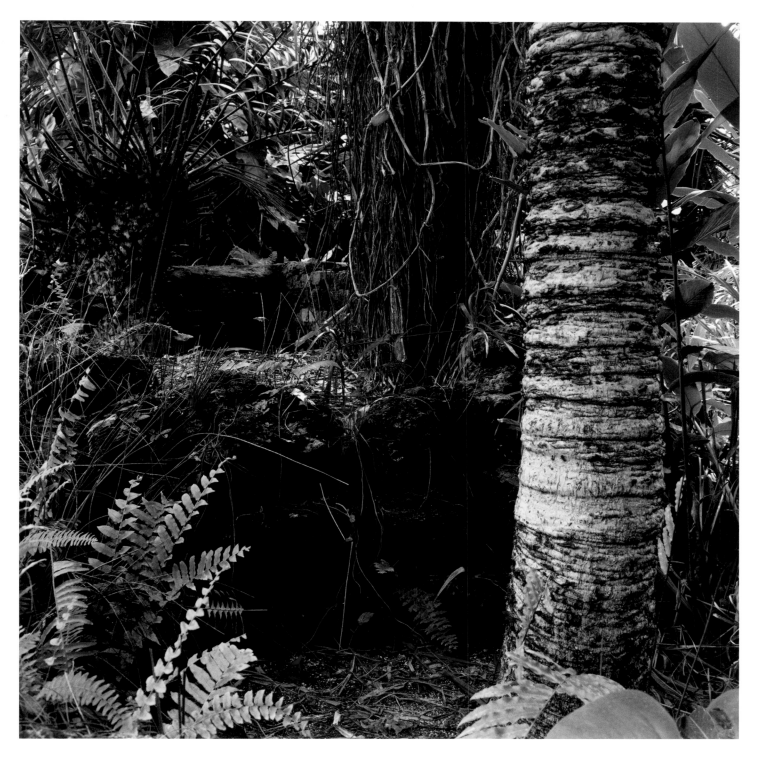

Garfield Park
PALM TREE IN FERN ROOM

*The lush tropical vegetation is
meant to evoke how the Chicago
region looked in prehistoric times.*

Marquette Park

Marquette Park was the largest of parks built under the 1904 expansion plan of the South Park Commission. The 323-acre grounds formed the centerpiece of the southwest-side Chicago Lawndale neighborhood, which had originally been marshland until a model town began to be developed there in the 1870s. Designed by the Olmsted Brothers along with Daniel Burnham, the park was named for French missionary Jacques Marquette, one of the first white men to occupy a habitation on the site of Chicago. It includes a Classical Revival field house, two lagoons, and a golf course, and over the years has been modified to accommodate a wide range of outdoor activities.

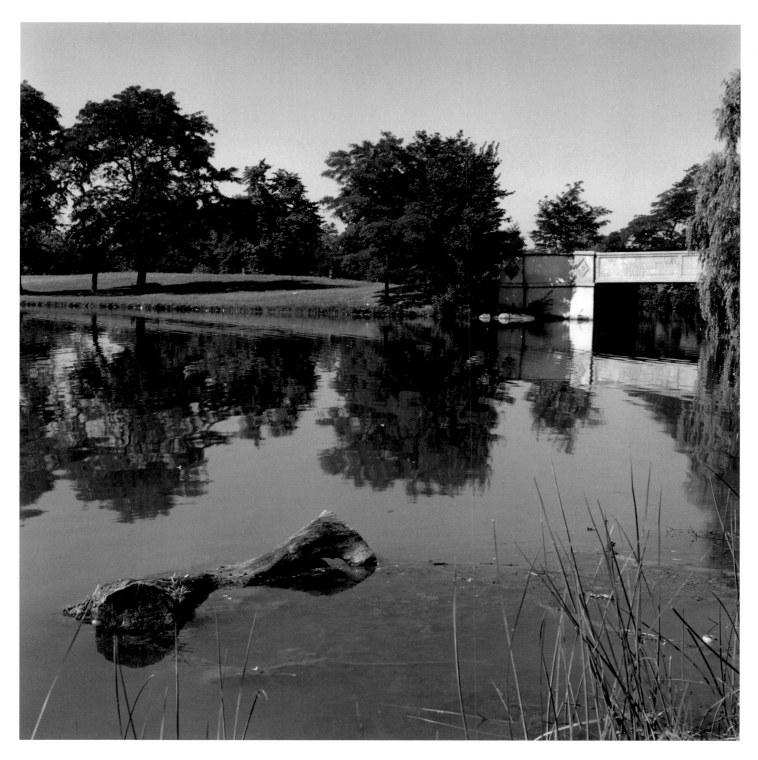

Marquette Park
MARQUETTE PARK LAGOON

Located on the southwest side, Marquette Park provides nature and recreation for its surrounding neighborhood.

Promontory
Point Park

Promontory Point Park – actually part of the larger, lakefront Burnham Park – was a former "sore thumb" at the foot of 55th Street in the Hyde Park neighborhood. The jutting point was built up with landfill by the mid-1920s, but wasn't improved until Works Progress Administration funding became available a decade later. In 1937 Prairie-style landscape designer Alfred Caldwell, a disciple of Jens Jensen, created a meadow with native trees and plants (that same year, he also landscaped the Montrose Point area on the north side). Caldwell's design was restored by the Chicago Park District beginning in 1987, and it is currently undergoing further renovations. The point features a circular stone fieldhouse modeled after a lighthouse.

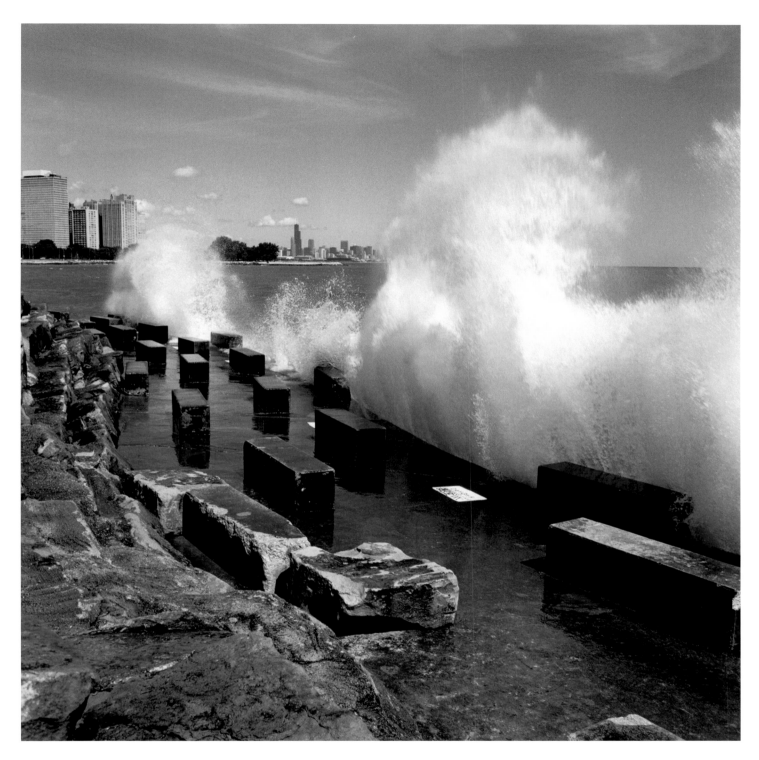

Promontory Point
WINDY POINT

*Restoration work on the extension
began in 1987, the 50th anniversary
of Alfred Caldwell's design.*

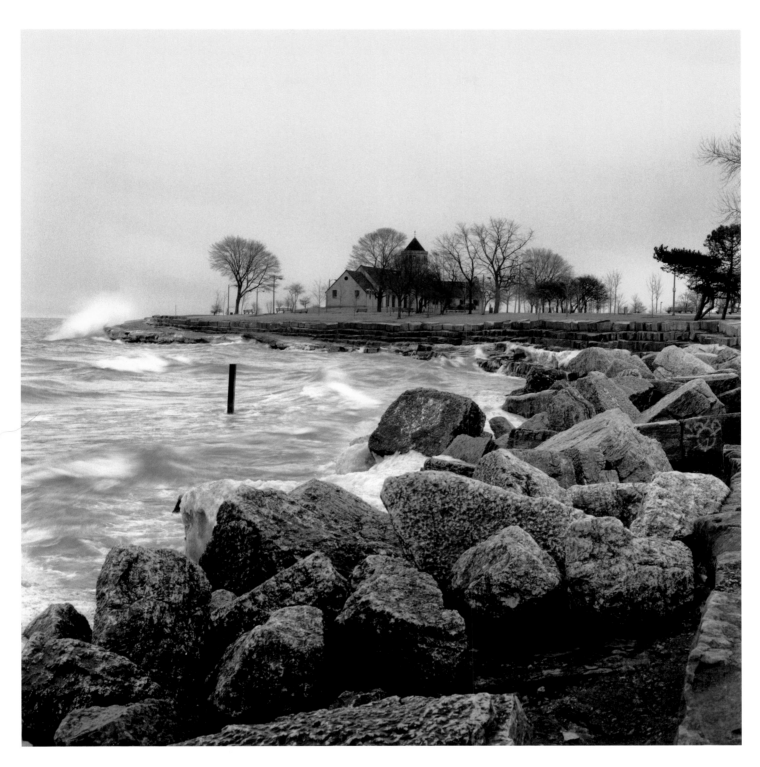

Promontory Point
STORM ON THE POINT

This point of land, an extension of Burnham Park, was landscaped in 1937 by Alfred Caldwell, a disciple of Jens Jensen.

South Shore Cultural Center

The South Shore Cultural Center, at 7059 S. South Shore Drive, began in 1905 as the South Shore Country Club when the area was largely undeveloped. The private lakeside club and golf course served the wealthy, and as a fashionable neighborhood grew around it, Marshall & Fox were retained to design a larger, more baronial Mediterranean-style structure in 1916. "The club and its grounds," according to a 1980s Chicago Park District inventory, "provides an interesting counterpoint to the civic effort to improve the public well-being through accessible park facilities." In 1974 the Park District purchased the 65-acre grounds and the original clubhouse was demolished a year later. The grandly elaborate interiors of the Marshall and Fox building with their commanding vistas were restored by 1983 in preparation for the building's new role as a community cultural center.

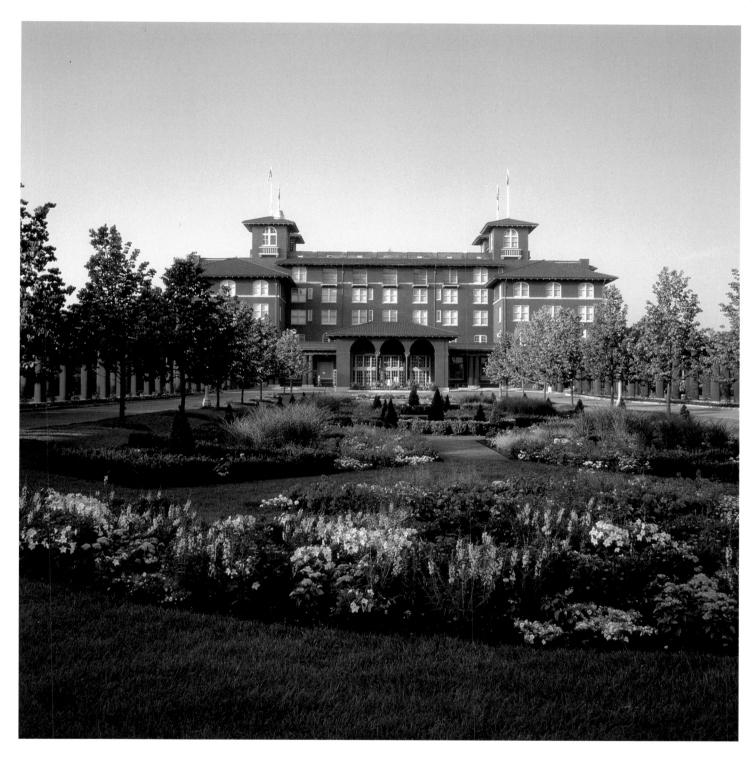

South Shore Cultural Center
THE CLUBHOUSE

*The South Shore Country Club was
originally built in 1916 by Marshall and
Fox as club for a golf course.*

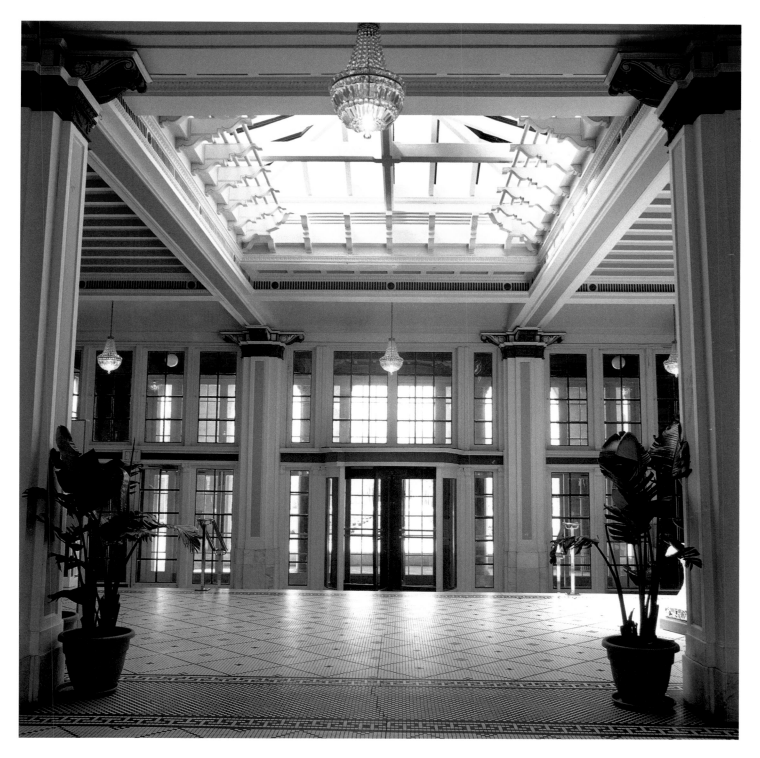

South Shore Cultural Center
MAIN LOBBY

*The main building was
beautifully renovated in 1983.*

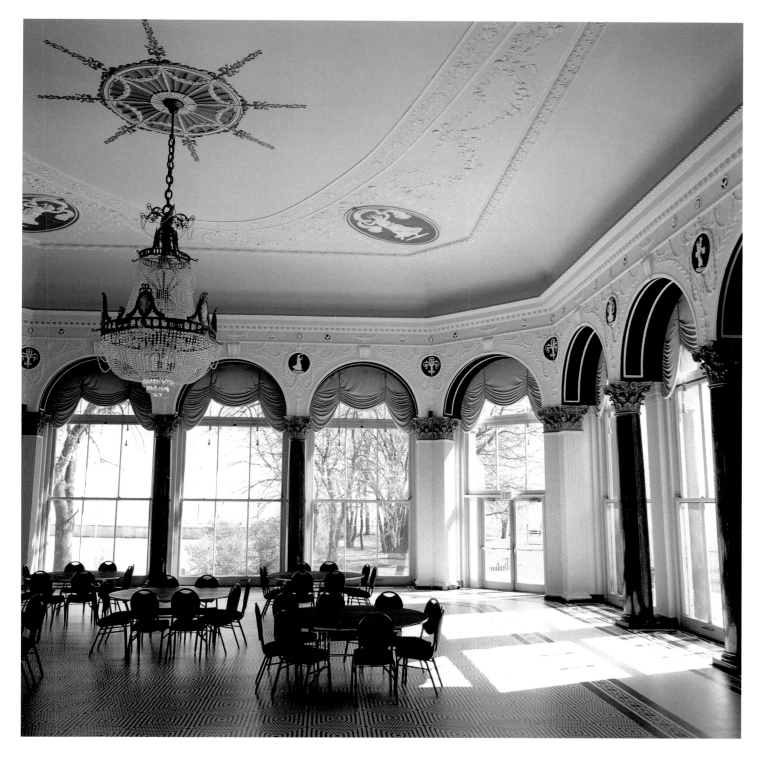

South Shore Cultural Center
Grand Ballroom

*The North Ballroom features
wall-to-wall windows that open
onto the adjoining terrace.*

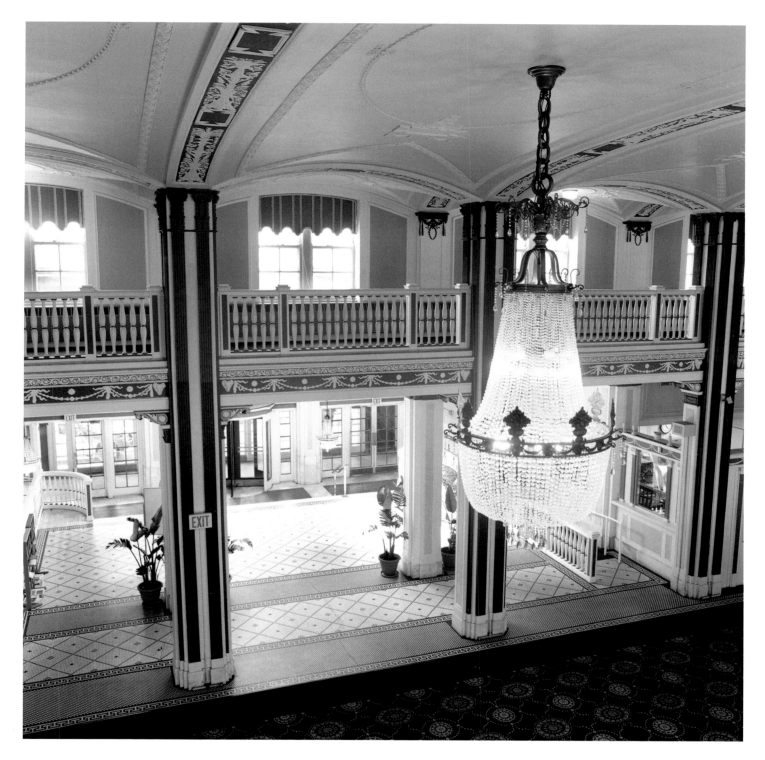

South Shore Cultural Center
LOBBY AND HALL

Spacious interiors can accommodate a host
of community and cultural activities.

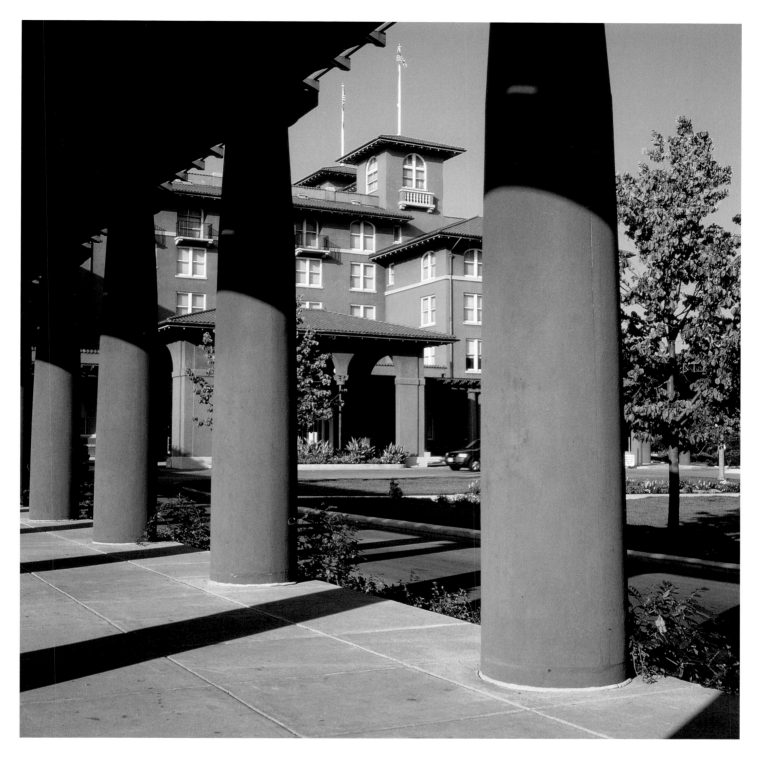

South Shore Cultural Center
COLONNADE VIEW

*The colonnaded driveway frames the grand
entrance offering expansive views of the grounds.*

Jackson Park

Jackson Park was originally planned by Frederick Law Olmsted and Calvert Vaux in 1871 as part of the 1,000-acre South Park that also included Washington Park and the connecting Midway Plaisance. But work on the swampy lakefront site didn't progress until two decades later when Olmsted & Vaux were chosen to design the grounds for the World's Columbian Exposition of 1893. Jackson Park, the fair's main site which comprises 543 acres, was transformed into a "White City" set in an aquatic paradise that featured a ceremonial basin, canals, a lagoon, a wooded island, ponds, and gardens. Major improvements were begun in 1895 by Olmsted, Olmsted & Eliot and completed in 1904.

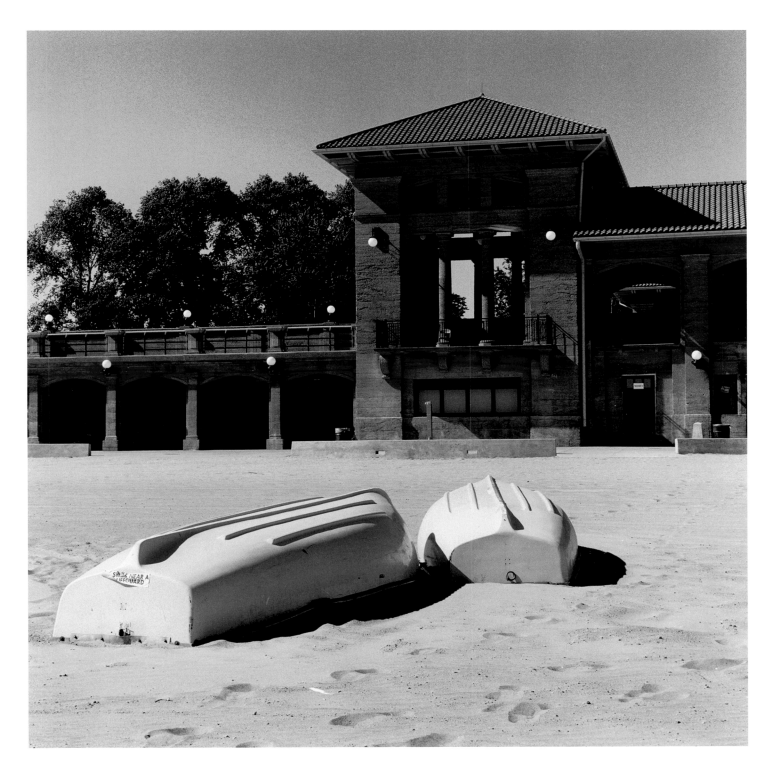

Jackson Park
63RD STREET BEACH HOUSE WITH BOATS

The 63rd Street Beach House opened in 1919.
It can accommodate over 2000 women and 3900 men.

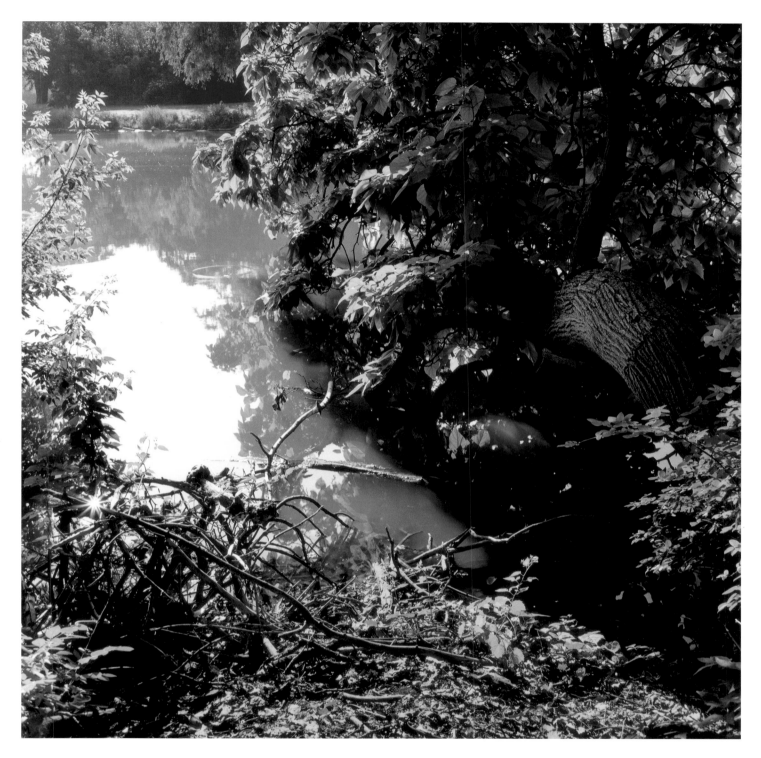

Jackson Park
Jackson Park Lagoon

*The Jackson Park Lagoon is one of the few
surviving remnants from the 1893 World's
Columbian Exposition, whose grounds were
designed by Frederick Law Olmsted.*

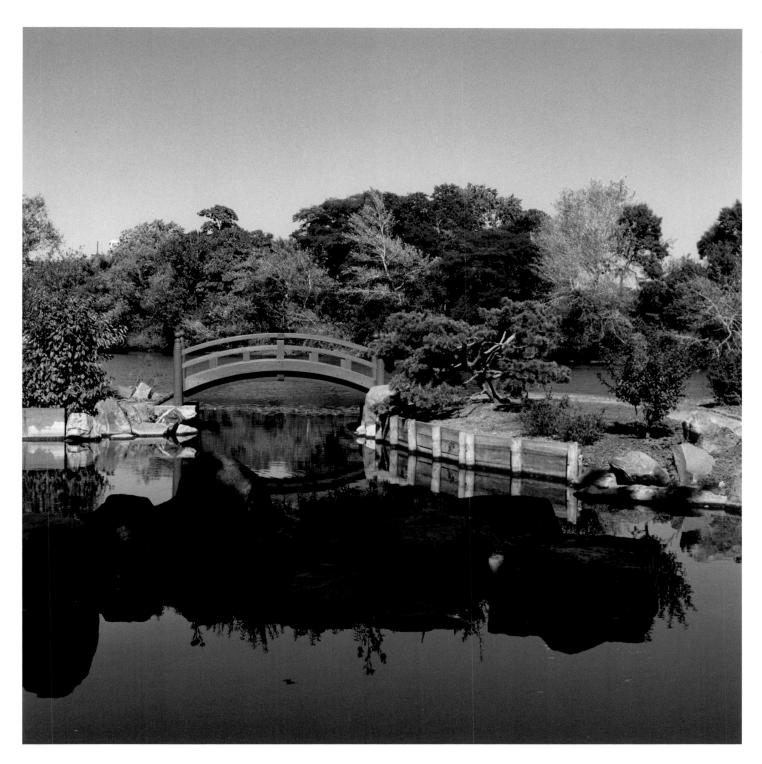

Jackson Park
OSAKA GARDENS

*This garden sanctuary is on the Wooded Island,
site of the Japanese pavilions during the 1893
World's Columbian Exposition; its remnants
were restored in 1981.*

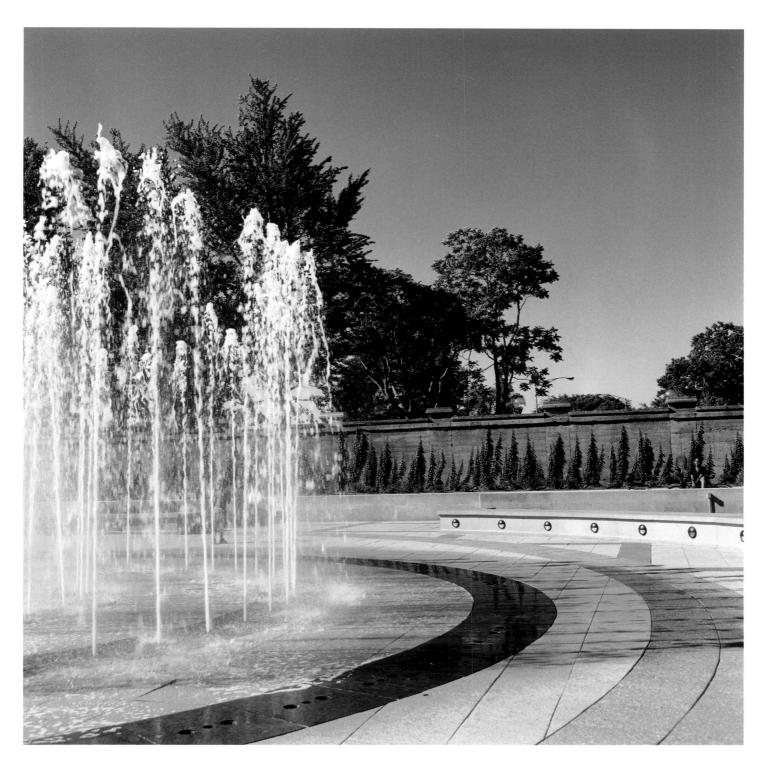

Jackson Park
63RD STREET BEACH HOUSE SPRAYPOOL

*This spraypool was added during renovation
of the Beach House in the 1990s.*

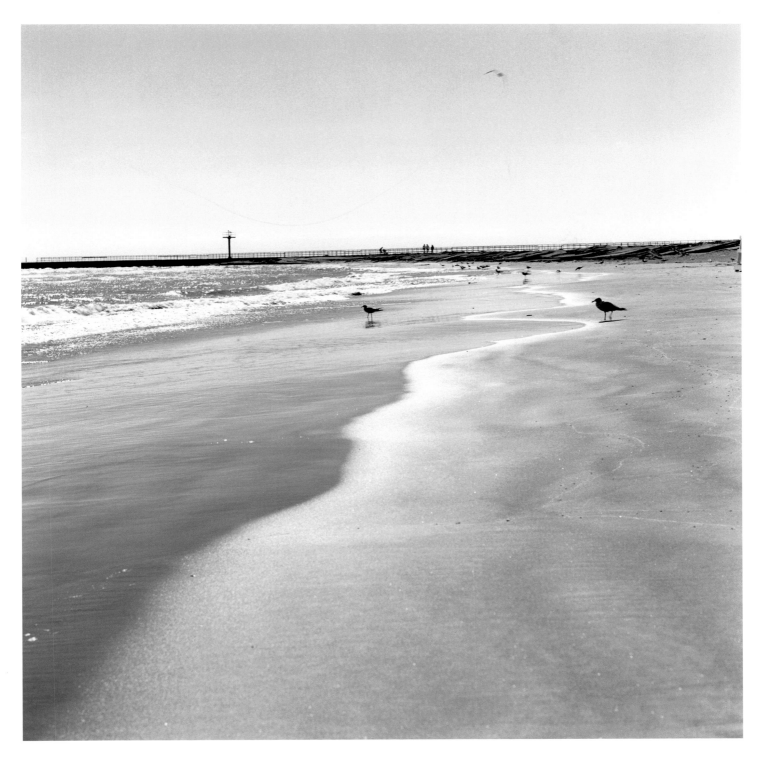

Jackson Park
63RD STREET BEACH SHORELINE

*Peaceful mornings with shimmering sand
and water are common on this beach.*

MAP OF FEATURED PARKS

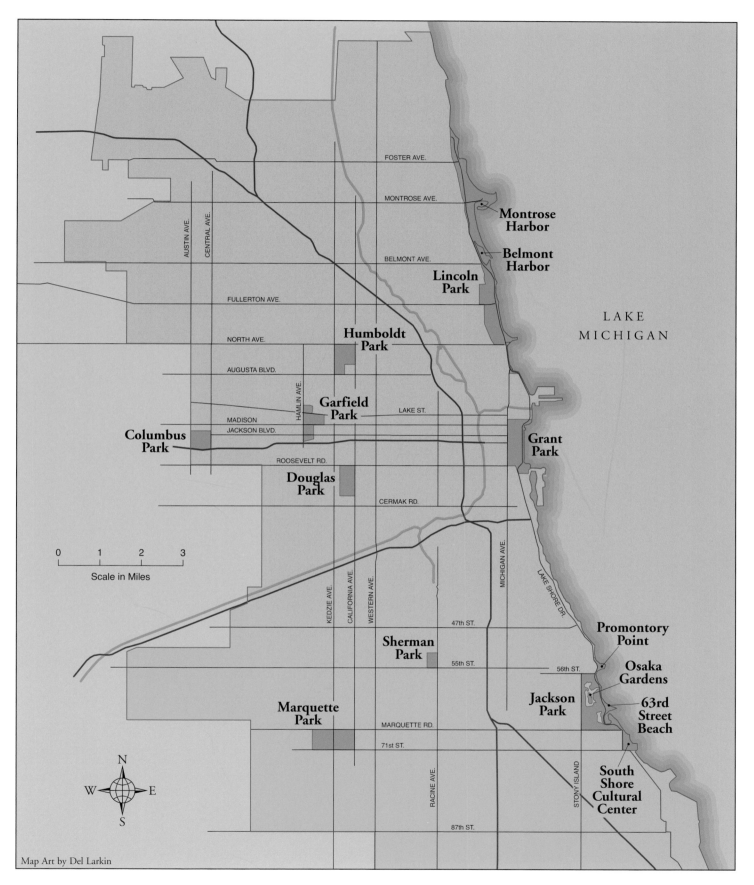

FOSTER AVE.

MONTROSE AVE.

Montrose Harbor

BELMONT AVE.

Belmont Harbor

Lincoln Park

LAKE MICHIGAN

FULLERTON AVE.

Humboldt Park

NORTH AVE.

AUSTIN AVE.

CENTRAL AVE.

AUGUSTA BLVD.

HAMLIN AVE.

Garfield Park

LAKE ST.

MADISON

JACKSON BLVD.

Columbus Park

Grant Park

ROOSEVELT RD.

Douglas Park

CERMAK RD.

0 1 2 3

Scale in Miles

KEDZIE AVE.

CALIFORNIA AVE.

WESTERN AVE.

MICHIGAN AVE.

LAKE SHORE DR.

47th ST.

Promontory Point

Sherman Park

55th ST.

56th ST.

Osaka Gardens

Jackson Park

63rd Street Beach

Marquette Park

MARQUETTE RD.

71st ST.

N
W E
S

RACINE AVE.

STONY ISLAND

South Shore Cultural Center

87th ST.

Map Art by Del Larkin

110

Sources consulted and Suggestions for Further Reading

Bluestone, Daniel. *Constructing Chicago.*
New Haven and London: Yale University Press, 1991.

Graf, John. *Chicago's Parks.*
Chicago: Arcadia Publishing, 2000.

Grese, Robert E. *Jens Jensen: Maker of Natural Parks
and Gardens.* Baltimore and London: Johns Hopkins
University Press, 1992.

Miller, Donald L. *City of the Century: The Epic
of Chicago and the Making of America.*
New York: Simon & Schuster Inc., 1996.

"Prairie in the City: Naturalism in Chicago's Parks,
1870-1940" (exhibition catalog).
Chicago Historical Society (in cooperation with the
Chicago Park District and the Morton Arboretum),
March 25-Oct. 27, 1991. Essays by Bart H. Ryckbosch,
Carol Doty, Julia Sniderman, and Wim de Wit and
William W. Tippens.

Rybczynski, Witold. *A Clearing in the Distance: Frederick
Law Olmsted and America in the Nineteenth Century.*
New York: Scribner, 1999.

Sinkevitch, Alice, ed. *AIA Guide to Chicago.*
San Diego, New York, and London: Harcourt Brace
& Company, 1993.

"Viewing Olmsted: Photographs by Robert Burley, Lee
Friedlander, and Geoffrey James" (exhibition catalog).
Canadian Centre for Architecture, Montreal, Oct. 16,
1996-Feb. 2, 1997. Distributed by MIT Press,
Cambridge and London. Edited by Phyllis Lambert.
Essays by Paolo Costantini and John Szarkowski,
interviews with the photographers by David Harris.

CHICAGO PARKS REDISCOVERED
was printed in Continuous-tone
Lithography by Black Box Collotype
Continuous-tone Printers,
Chicago, USA.

Bound by
Roswell Bookbinding, Phoenix, AZ

Designed by
Phillip Ross Associates, Ltd.

Images for this book were
photographed with
Kodak color negative film,
printed on Kodak Ektacolor paper,
and scanned on a custom
Isomet drum scanner.

Paper: SAPPI, 100 lb. Lustro Dull Text.
Toyo Ink

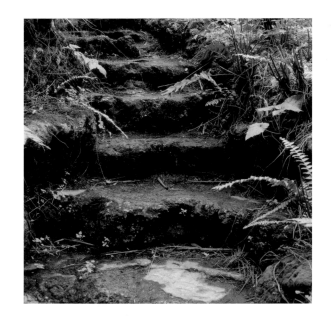